iNCiTE
Dreams Realized
THE BEST OF MIXED MEDIA

Edited by Tonia Jenny

NORTH LIGHT BOOKS
Cincinnati, Ohio
CreateMixedMedia.com

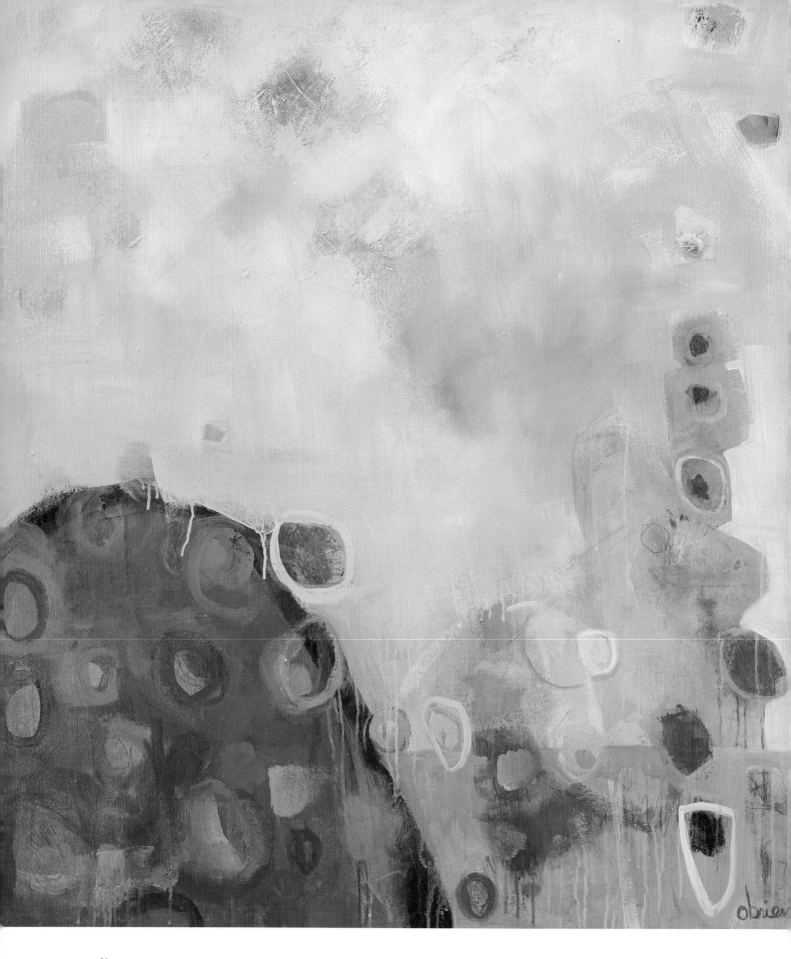

"My dream of 'going big' was realized when I began to paint my feelings rather than just the object."

• Annie O'Brien Gonzales

Contents

Tulipmania

Annie O'Brien Gonzales | 48" × 48" (122cm × 122cm) | mixed media on panel

When I resumed painting after considerable time off to deal with "real life," I started small because small was all I had ever done. I would marvel at the large abstract paintings I saw in galleries and museums. My love of flowers and gardens as subject matter kept tugging at me, so I painted many small flower paintings.

Finally, my dream of painting large, abstract paintings compelled me to buy a 48" × 48" (122cm × 122cm) panel and go big! I wasn't sure how my floral work would translate to a large canvas, but I decided to go for it.

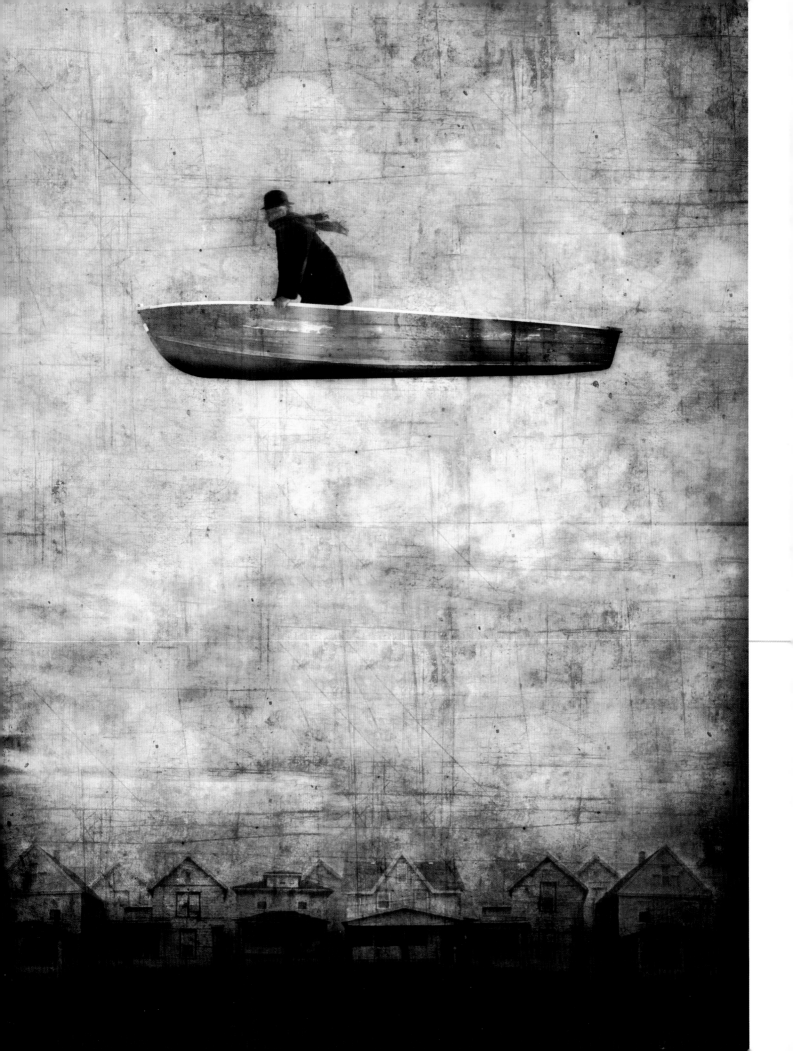

Dreams Realized

"I may not make art every day, but I dream about what I want to achieve as an artist every day, and sometimes that's enough." · Colleen E. Monette

The Boat

Michael Weiss | 20" × 28" (51cm × 71cm) | Nikon CoolPix camera, Adobe Photoshop CS3

The process I used to create this image wasn't new to me, but it was the first time I felt confident enough to market and sell my work. Since creating *The Boat*, I have been able to develop a much stronger portfolio that is unified by the technique. It was this image that pushed me to display my work in a gallery and feel comfortable talking about it.

Over the past few years, my work has fallen into this playful, fanciful and surreal world. It is a joy to dance in the clouds and create these dreamlike images. I usually have a story or path on which I travel for the work, but I try not to reveal too much to the viewer, allowing their own interpretations to guide them through the image.

"It is my job as an illustrator to create visually what a writer puts into words; not to compete with, but to complement a story." · Michael Weiss

Welcome to the premiere edition of *Incite*! I'm excited to share with you this compilation of some of the very best art coming from artists who love creating in the vein of mixed media.

As a North Light Books acquisitions editor for the category of mixed media, I've had the honor and privilege of learning from so many talented artists over the last decade (many of whom have had a direct impact on my own art practice) and have known for years that a book containing a collection of this level was possible. (Selecting the winning pieces was challenging; I wish we could have included more!)

If there's one thing I've learned about the mixed-media artist, it's this: The free spirit that embraces mixed media is not afraid to take risks and to explore new ground. After all, I think it's the desire to try new things and new combinations of materials that makes someone a mixed-media artist in the first place. And you'll see many examples of this fearless approach on the pages to follow. Like Mel Grunau says, "When pursuing your dream, don't be afraid to experiment. Try something new. You may be pleasantly surprised."

The theme we chose for this first *Incite* edition is "Dreams Realized." Dreams are comprised of many facets, and as artists, we have no shortage of artistic dreams—intentions of success, messages we hope our work conveys, triumphing over challenges and realizing self-growth, just to name a few directions these dreams can take.

Because of the beautifully wide scope that is mixed media, you're going to be inspired here by works from a variety of approaches—collage, acrylic painting, assemblage, sculpture and more. Whatever your own favorite materials to work with are, I think you'll be inspired to try new things and to create new dreams after you've seen some of what's possible. I like the advice of Gayle Gerson:

"Remember, doing art is never a waste of time, even if it doesn't turn out as you desire, because as you work, you enrich your creative soul and take a few steps more toward realizing your artistic dream."

So make yourself comfortable and enjoy the amazing artwork that follows. I hope it inspires you to pursue your own dreams.

· Tonia Jenny

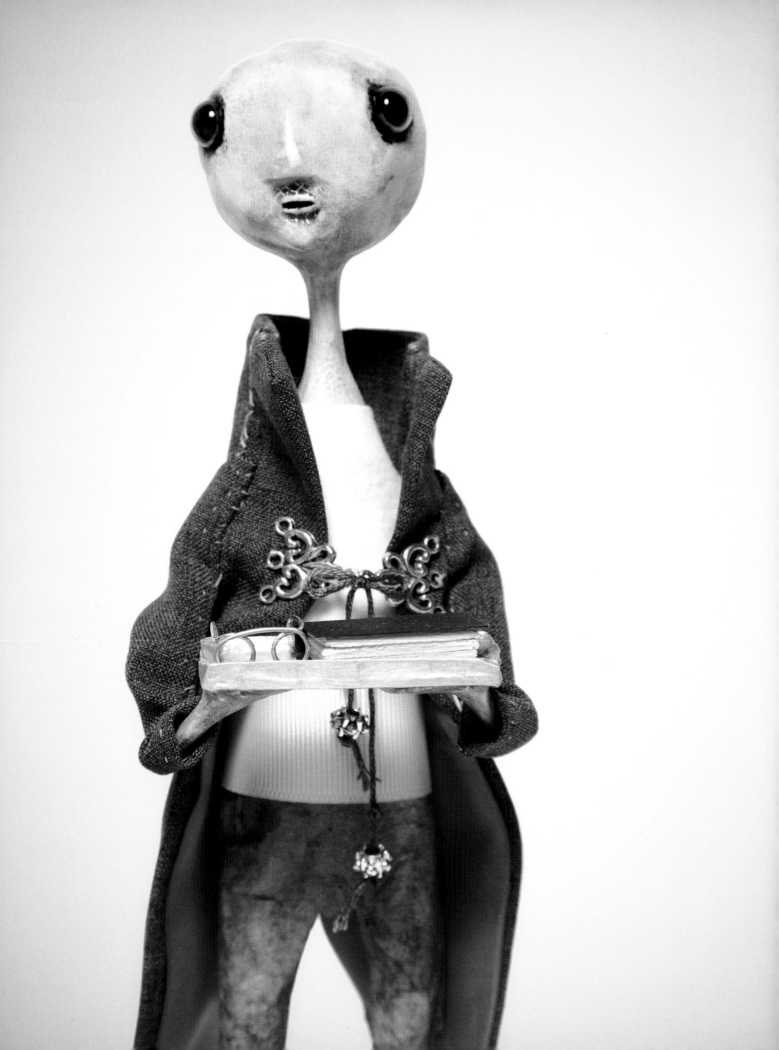

The Stuff of Dreams
Dreamy Visions, Dreamlike States, Dream Interpretations

The dreams one has at night are often re-expressed in the art one creates from the imagination, because the imagination is no stranger to the dream. Conversely, many artists fall into a dreamlike state when they are in the flow of creation, and the art that comes out of them is as intuitive as any dream the subconscious works up.

Pat Stevens understands how dreams are a combination of emotions, symbols and seemingly mysterious messages: "By using nontraditional materials and new techniques, mixed-media work often breaks the binds of traditional art and enters a less-defined area similar to the dream state."

Whether we are trying to create a dreamy experience for the viewer of our art, or we are pulling personal symbology, iconography and metaphors from what we recall of our dreams to use in our art, art often begins as a dream.

The Servants of Ord, detail

Karen S. Furst | 12" × 12" (30cm × 30cm) | painted epoxy clay, aluminum foil, Styrofoam, muslin and wool fabric, stained coffee filters
photography by Luigi Ciuffetelli | see artist's note on page 12

"Anyone can realize their dreams, if they approach art as an experimenter with a playful heart, leaving judgment at the studio door." · Kathy Kostka Constantine

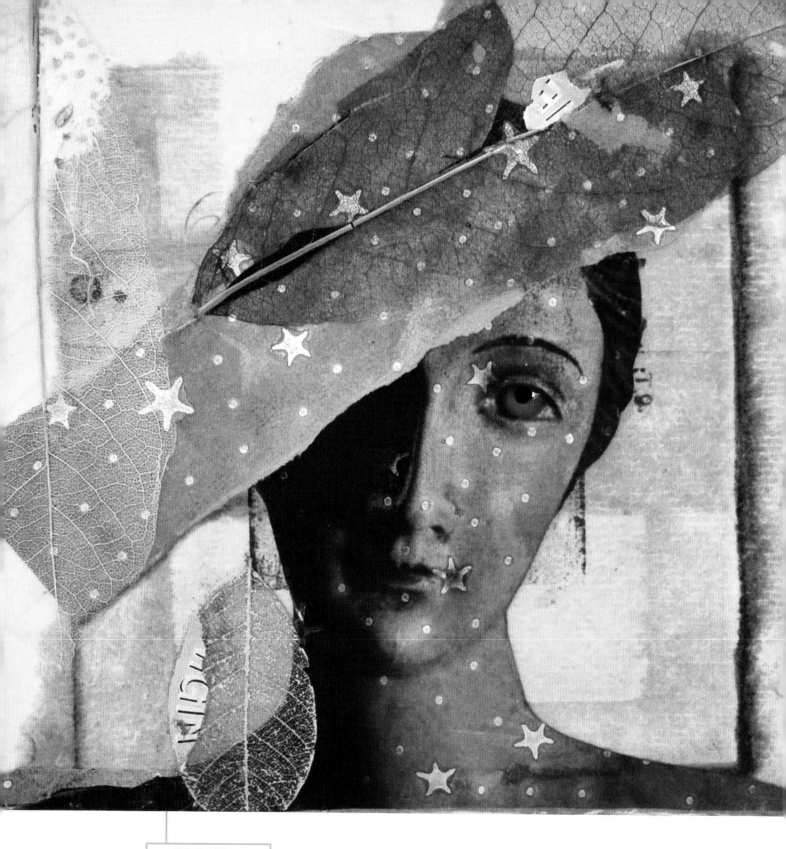

Night Sky

Trudi Sissons | 6" × 6" (15cm × 15cm) | mixed media on rice paper, Craft Attitude film overlay, watercolor, vintage ephemera, skeleton leaves on cradled wood panel

Shortly before my father-in-law passed, he told his son that upon his passing, he would return to the stardust from which he came. This notion gives my muse endless creative imagery as I attempt to communicate visually how, as sentient beings, we are all a part of each other—one energy, one flow. The semitransparent female figure in *Night Sky* attempts to echo this belief, reflecting the stardust that flows through her.

Dedicated to Dr. Gilbert Rampling, 1924–2010

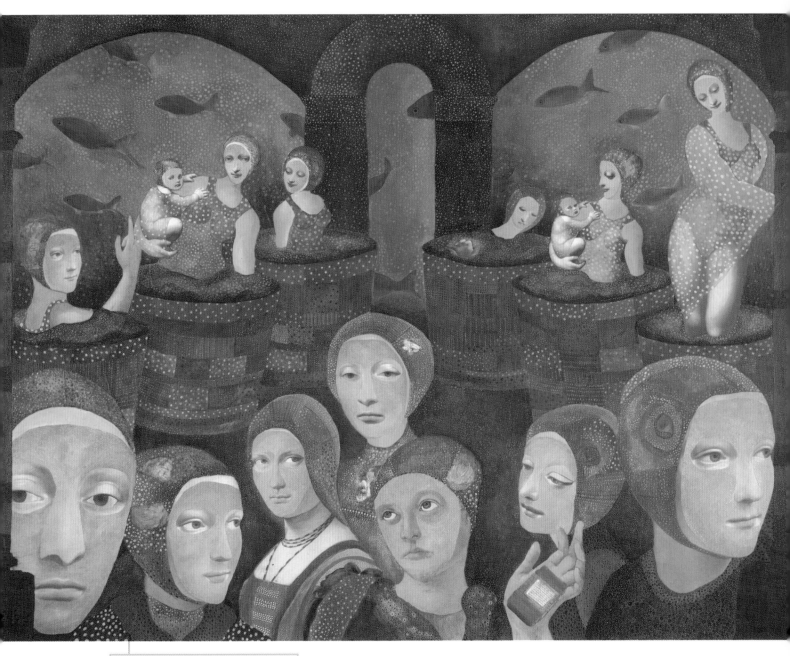

Leonardo's Day Spa

Mariette Leufkens | 36" × 48" (91cm × 122cm) | color photocopies, acrylic paint, paper, plastic on canvas

Leonardo's Day Spa was inspired by a trip to Florence, Italy.

Nothing is more rejuvenating and dreamlike to me than soaking in hot, steaming, outdoor mineral baths! Earth's most essential resource, water, has been used for centuries to soothe and restore the body, mind and spirit. My dream was to create a day spa for Leonardo da Vinci's famous women—apply clay facial masks, put them in bathing suits, soak them in water—which resulted in this surreal gathering on canvas.

I spent endless hours painting and then blending the textures, details and colors into a smooth matte finish. Small brushes are my absolute favorite tools.

Dreams

Mary R. Rork-Watson | 36" × 24" (91cm × 61cm) | mixed-media collage with acrylic paint on Ampersand Gessobord

I considered throwing this artwork out when I finished it the first time. I propped it against my studio wall and stared at it for days, until humbly accepting the work was not telling a true story. So I started over. I sanded away layers of paint and scratched off unwanted images, deliberately leaving evidence of this effort.

When I stopped trying to force the process, my skills and creativity were able to deepen my original intention. Each new layer of color, texture and collage blended with these marks and scratches to reveal a piece rich with artistic honesty that tells the story of a dreamer.

Detail, *Microcosms Part I*

Microcosms, Part I

Valerie Lewis Mankoff | 30" × 22" (76cm × 56cm) | liquid acrylic, collage, mark making, stamping, rubbing alcohol on 140-lb. (300gsm) hot-pressed watercolor paper

As a retired psychologist, I believe art derives from unconscious dreams and fantasies. My artistic intention in conceptualizing my **Microcosm** series was to create abstractions of fantasy worlds.

This piece represents a dream realized. It is my first painting where I gained control over communicating my vision in a direct way, using layering techniques I have been developing for the past five years. The combined media produce surprising effects and create depth and mystery.

" *To realize your own dream, write it down and hang up the paper in a place where you will see it often. Give yourself permission to be creative, to be an artist and to succeed.* **"** · Karen S. Furst

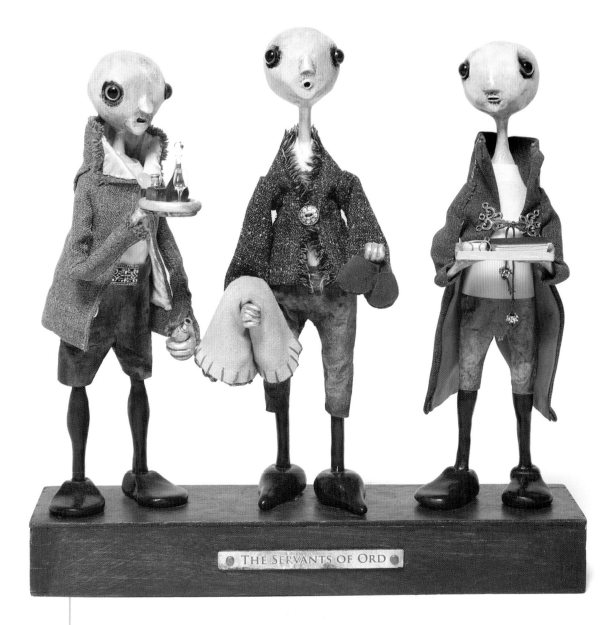

The Servants of Ord

Karen S. Furst | 12" × 12" (30cm × 30cm) | wooden box, painted epoxy clay, aluminum foil, Styrofoam, muslin and wool fabrics, stained coffee filters
photography by Luigi Ciuffetelli

Friends have always remarked that I live in my own little dream world. They are right! My world is populated with radical robots, damaged dolls, quirky creatures and maniacal monsters, inspired by fantasy, folk tales and dreams. They materialize out of my imagination and are ushered into this reality with clay, paint, found objects and recycled household items. For *The Servants of Ord*, I built an armature from wire and aluminum foil and added layers of epoxy clay and paper clay, followed by paint, hand-sewn clothing and other details. The alien figures exude an eerie quality, leaving one to wonder about their true purpose in serving Master Ord.

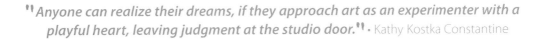
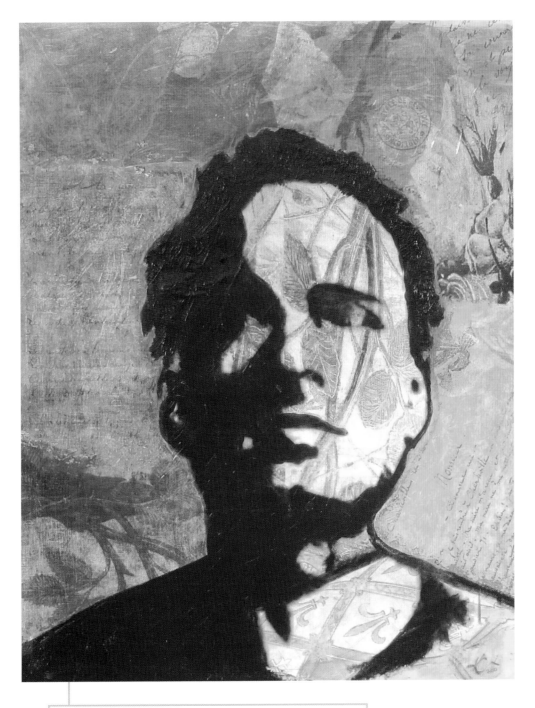

Souvenirs de Paris (Memories of Paris)

Kathy Kostka Constantine | 30" × 24" (76cm × 61cm) | acrylic, printed tissue, gel medium, gold foil on Strathmore acrylic paper

Memories of Paris expresses the mystery of memory and the way it is composed of fleeting images and scraps of experiences that move through both our waking hours and our dreams.

This piece was inspired by a letter, in French script, posted in a Paris store window. In the letter, I saw the word "souvenirs," which I interpreted to mean the things one buys to remember a trip. Later, I found out that it actually means memories. My inspiration was that the only real souvenirs are the memories we take with us and shape over time. This piece was thrilling for me because I realized my dream of authentic expression.

"Every day I contribute by drawing one line at a time." · Patricia Bradley Bereskin

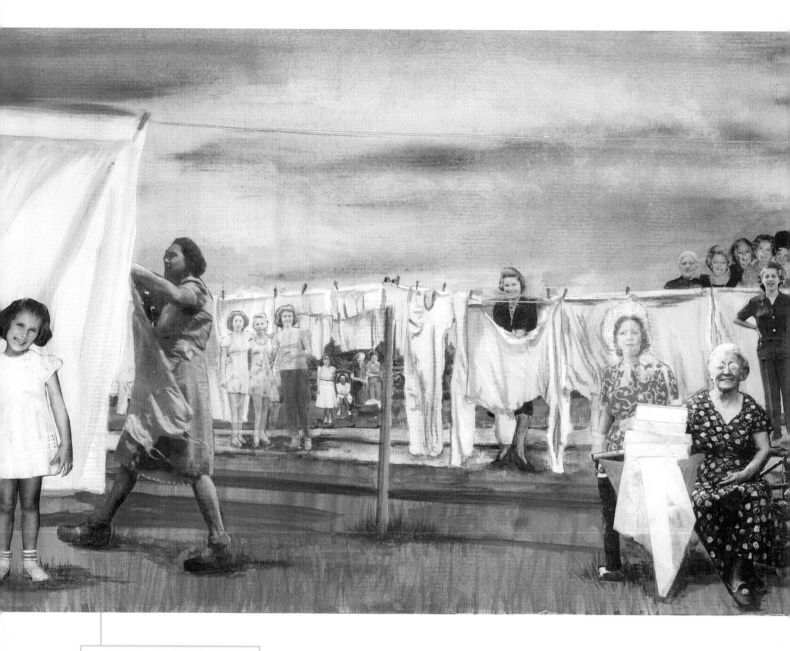

Between the Lines

Patricia Bradley Bereskin | 13" × 18" (33cm × 46cm) | watercolor, photographs, cotton string, wood, tissue paper on 300-lb. (640gsm) matte board

Ten years ago while I was recovering from emergency surgery, I had a vivid dream of the flapping sound of sheets drying on clotheslines in the summer. As I walked past the rows of sheets and laundry, there, tucked between each line, were the women of my family who had passed away. They smiled at me and talked to me, but I couldn't hear their words—I could only feel their intentions.

The dream haunted me for two years. After a variety of mediums and several tries to re-create the scene from my head, I put the project aside. Months later, it all came together when a photo of my grandmother hanging sheets on a line fell from a book.

That was the beginning of this picture. I found all of the women among the photos. They had crossed oceans, left family, encountered tragedy, lost children and husbands, suffered and been poor, hungry, lost and more. They survived everything life had thrown at them with dignity and grace.

By sizing, cutting and gluing them into place, I became even more intimately aware from this dream that their daily lives allowed me to be who I am and to be present at this moment to add to the line.

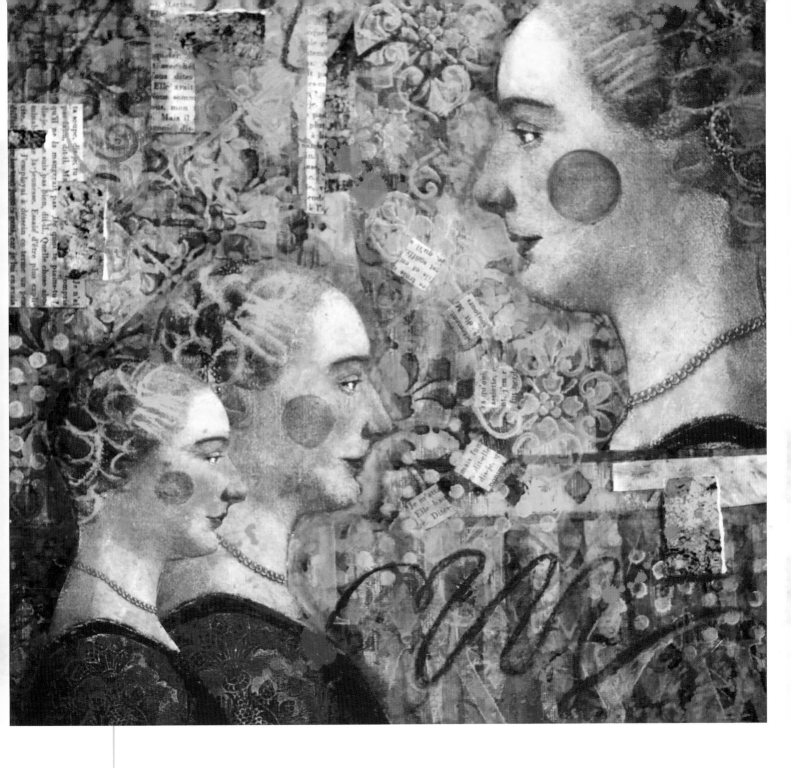

From The Tapestry of Truth and Beauty

Pat Stevens | 12" × 12" (30cm × 30cm) | gesso, acrylic paint, pastels, toner copies, hand-painted paper on canvas panel

This piece is part of a larger work entitled, *The Tapestry of Truth and Beauty*. Consisting of nine square panels arranged in three rows of three, it is a present-day take on antique icons. The piece is modernized by the use of bold colors, multiple layers of pattern and texture, and the repetition of the central image as a sort of homage to pop icon Andy Warhol.

My mixed-media work can be compared to dreams, because dreams are often a combination of verbal, visual and emotional stimuli that form mystifying narratives or intriguing representations. By using nontraditional materials and new techniques, mixed-media work often breaks the binds of traditional art and enters a less defined area similar to the dream state.

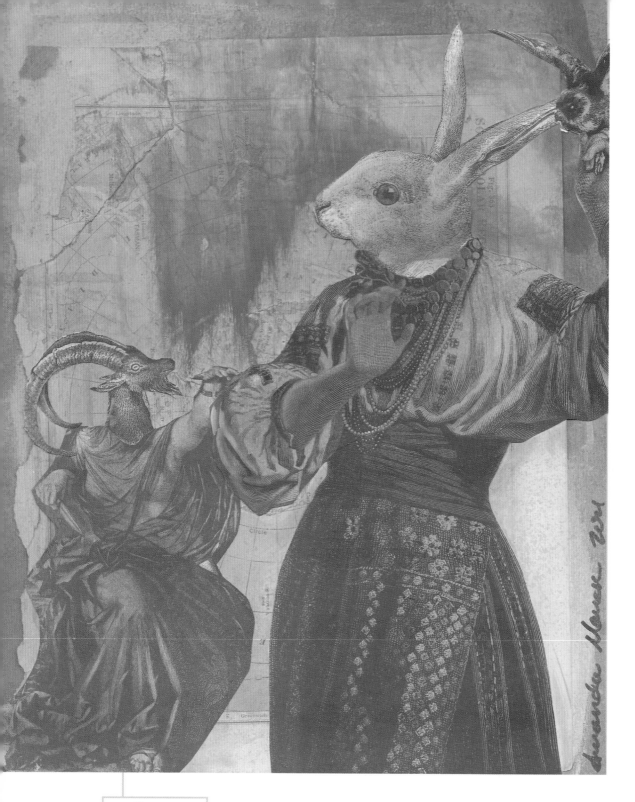

Gypsy

Amanda Beck Mauck | 11" × 9" (28cm × 23cm) | mixed media, paint, ink on paper

My work is a direct response to dreams realized. Through archetypal themes such as birth, escape, captivity, conflict and impotence, I reinterpret the world and convert it into something completely "other." Hands, umbrellas, mirrors, feathers and tools symbolize those urges, wishes and terrors that we would censor in the waking state.

I use ethereal colors and loose lines to capture the whimsical, curious and inexplicable—our unconscious wishes and urges. Not knowing what is coming next and the anticipation of what lies just beyond our sight is thrilling, yet we find a familiarity with each narrative. We share a universal truth with every other creature, both real and imagined.

"I may not make art every day, but I dream about what I want to achieve as an artist every day, and sometimes that's enough." · Colleen E. Monette

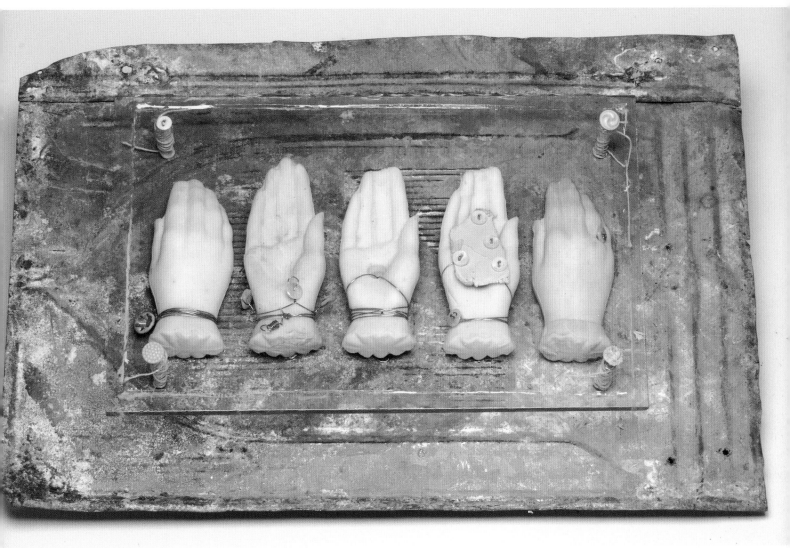

Hands

Colleen E. Monette | 10" × 14" × 3" (25cm × 36cm × 8cm) | glass, tin, vintage soaps, buttons, wire, wax twine | photography by Jeff Goble Photography

I am a collector of things—old French things, bits and pieces. I dream about them. It's taken years to realize that they've been waiting to be my art. These wonderful hands are vintage soaps, attached to an old piece of tin using brass wire. I've carefully drilled through the soaps to embed buttons, and covered them with an old piece of glass. The entire piece rests on little glass feet. It serves as my bedside tray, collecting its own bits and pieces throughout the day. My hands created *Hands*, and it's truly a dream realized.

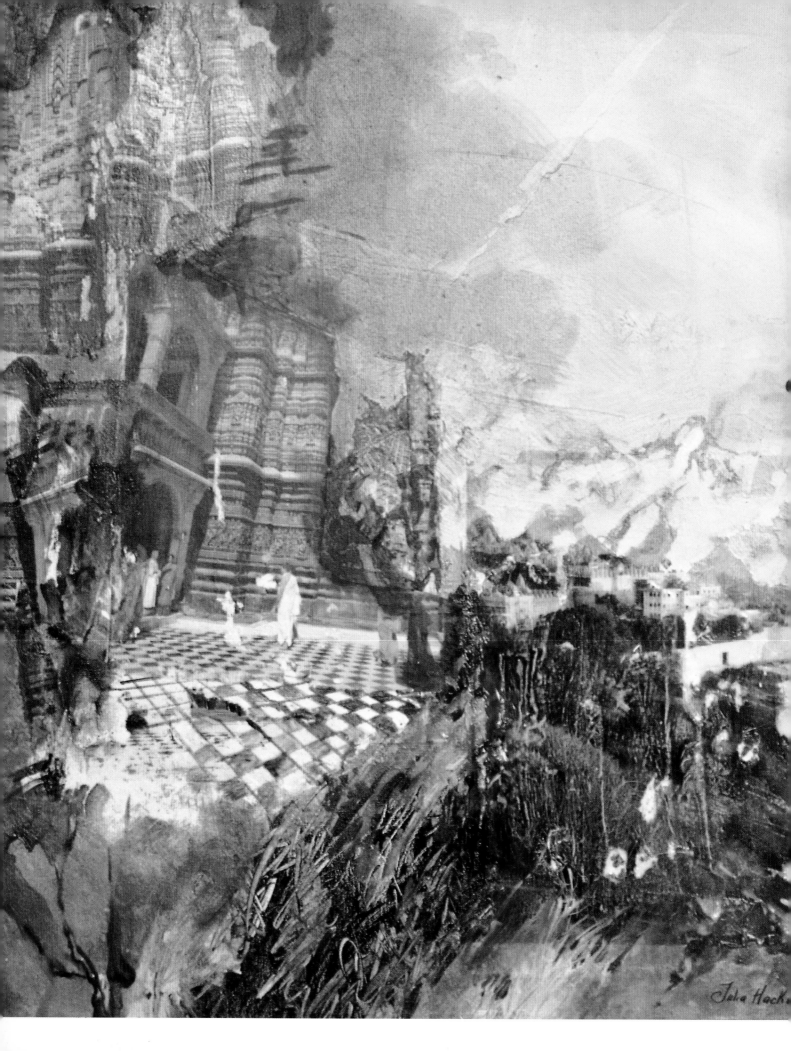

Artful Escapes
Travel, Relaxation, Art as Therapy

For any artist, the act of going into the studio and locking the door is an escape that can rival any travel to a foreign place. But at the same time, the memories of our actual travels—the things we recall smelling, hearing, seeing—provide inspiration for some of our most authentic works, as Nancy Stanchfield shares: "A dream realized for me was the opportunity of attending an art workshop in France! This experience helped to shape the course of my painting career."

At other times, the concept is a bit more abstract when our motivation behind creating a work of art is to have the viewer experience an escape of his or her own, simply by taking in our art—be it a sense of joy, playful curiosity or thought-provoking questions for our inner selves.

Sometimes the creative process is an escape, and sometimes we reinterpret our past actual escapes or the escapes that have existed only in our minds, but which we dream of making.

Travel Diary

Julia Hacker | 20" × 20" (51cm × 51cm) | mixed media on gallery-style canvas | see artist's note on page 24

" I love traveling. There is nothing better for my heart and mind." · Julia Hacker

> "*I often spend a lot more time thinking about what I want to accomplish in a painting than completing the actual painting process. So in that sense, the resulting painting is a dream realized.*" - Sandie Bell

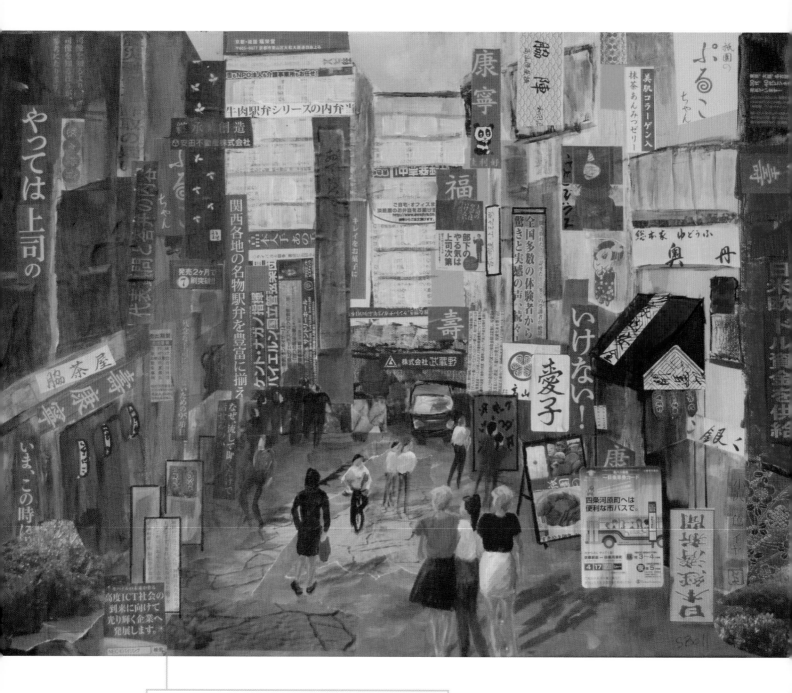

Japanese Marketplace (Veno Amoyoko)

Sandie Bell | 18" × 24" (46cm × 61cm) | acrylic paint, paper collage, permanent marker on stretched canvas

Recently I was fortunate enough to visit Japan for almost four weeks and stay with a Japanese family. We went to quite a few busy traditional markets, but this one in Tokyo was enormous and packed with shops and people. After returning home, I wanted to capture the busy, colorful, crowded feeling without rendering everything realistically. I decided that incorporating some paper items that I had brought back from Japan would convey the sense of the place. The tall buildings in the background are an acrylic paint layer, a Japanese newspaper layer, more paint and then some larger type from the newspaper and other sources. Most of the signs are from brochures, menus, chopstick wrappers, tickets and anything else I could find.

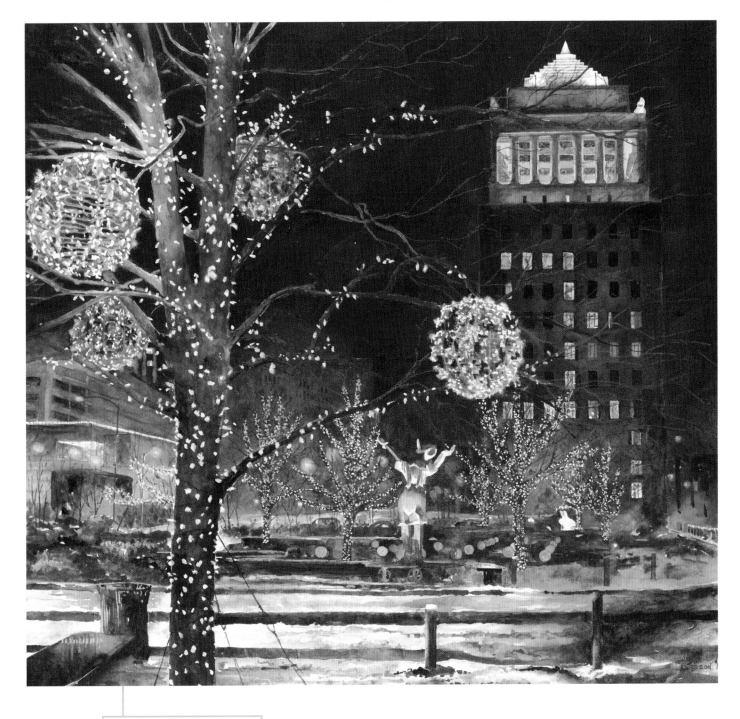

'Tis the Season

Daven Anderson | 21" × 22" (53cm × 56cm) | watercolor, pastel, colored pencil on 300-lb. (640gsm) Arches cold-pressed paper

'Tis the Season is a painting of the conceivable and the imaginable. Jim Dine's statue of Pinocchio, in St. Louis's Citygarden, with its arms upraised, celebrates life and all that it means and embodies. My work, painted in the context of the holiday season, is meant to extol the possibilities of life, of being.

The scene was painted in a winter holiday setting to emphasize the beauty of the moment. The challenge was to capture in watercolor the majesty and drama with all of its strong contrasts and subtle value shifts. The branches reflecting the holiday lighting against a dark sky were particularly challenging. I used both pastel and colored pencils to render them as well as to emphasize color and contrast.

Promenade

Nancy Stanchfield | 30" × 36" (76cm × 91cm) | collected papers, acrylic paint on canvas

A dream realized for me was the opportunity of attending an art workshop in France! This experience helped to shape the course of my painting career. Traveling through France, I discovered my affinity for the French aesthetic of architecture in all of its elegance, humbleness and crumbling history. In portraying my impressions of these structures, they have taken on human characteristics—personalities hinting at a colorful past, wisdom withstanding the test of time or joyful beings amid gaily painted shutters and doorways. Applying multiple layers of paint, collage and glazes, I created a patina of architectural antiquity, while a bright color palette adds an energetic slant.

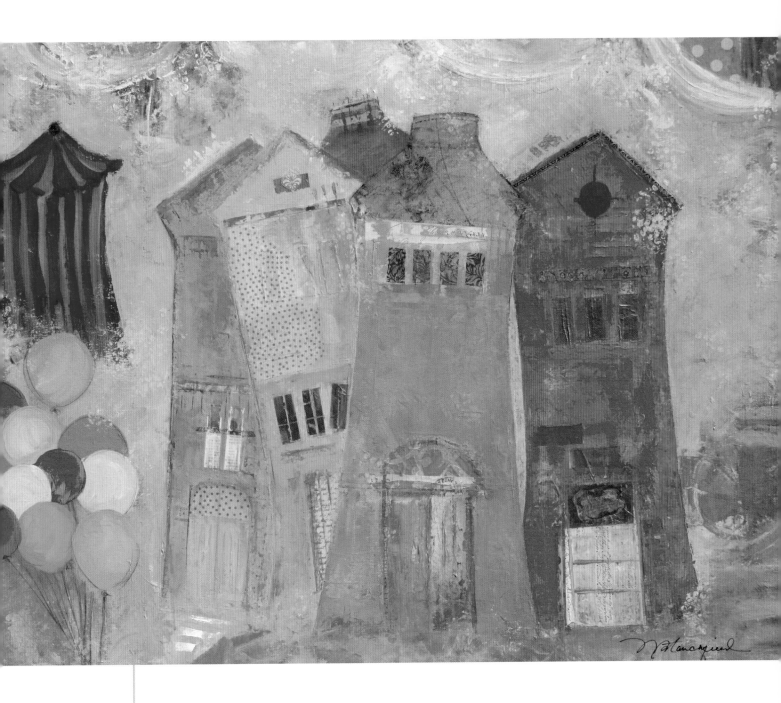

Carnaval

Nancy Stanchfield | 36" × 48" (91cm × 122cm) | collected papers, acrylic paint on canvas

Foremost in my thought while creating art is a sense of spontaneity, imagination and joy. In *Carnaval*, playfully abstracted architectural elements suggest an atmosphere alive with fun and frivolity. The buildings—are they attending the carnival, or has the Carnaval just arrived in the neighborhood? I wanted the viewer to participate or engage his imagination and make the story his own. As in *French Façade* (in the "Artistic Awakenings" chapter) and *Promenade* (opposite), I used various French papers and postcards to strengthen the theme of French architecture.

Travel Diary

Julia Hacker | 20" × 20" (51cm × 51cm) | mixed media on gallery-style canvas

I love traveling. There is nothing better for my heart and mind.

In the *Travel Diary* series, I am recounting places I visited or want to see—real and imagined—and asking what stays in our memory after visiting other places: color, shapes, smells, etc.

In this work, I used an acrylic transfer technique, paper collage and acrylic paint to create a dreamlike image of the country in the Far East. I started with collage and continued with layers of thin washes of acrylic paint, adding acrylic transfer and finishing with gestural brushwork in order to create the foreground.

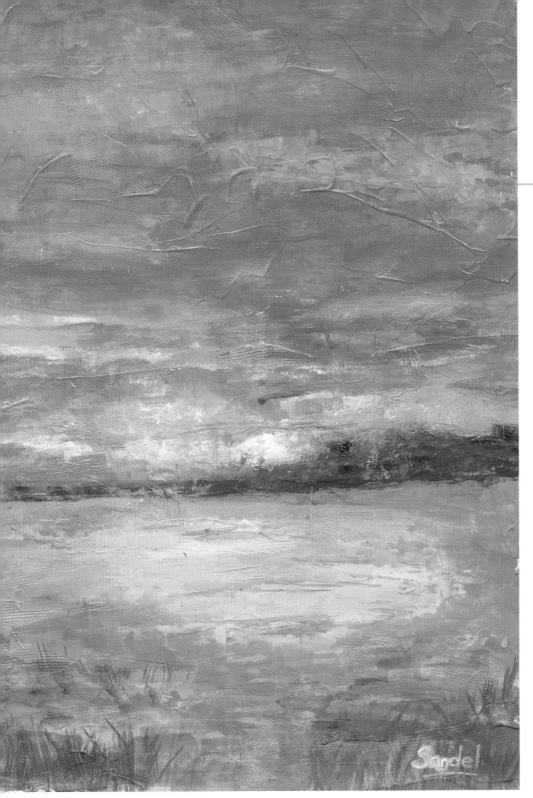

Copper Field

Sharon Sandel | 22" × 14" (56cm × 36cm) | transparent and opaque watercolors, gel medium on copper leaf, 140-lb. (300gsm) cold-pressed watercolor paper

I started painting in 1978 in the evenings after working all day as an elementary school teacher. It was my pressure-release valve. My dream of doing a lot of art has been realized in the past three years since I retired.

My technique on this piece was to take a failed painting and cover it with gel medium (Golden) and then attach a layer of copper leaf through the midsection with matte medium. After it dried, I painted with my two favorite watercolors: Andrew's Turquoise (American Journey) and Naples Yellow (American Journey), along with accents of Jaune Brilliant (Holbein).

The theme reflects my love of the sky colors in both Florida and North Carolina (I live in Florida in the winter and North Carolina in the summer) against the wonderful fall colors I see in North Carolina. It is a dream realized to do watercolors in nonstandard ways. I find doing watercolors in nontraditional ways very liberating, and I like to pair them with textures of many different types.

"*Just let yourself go, and don't worry about the outcome. Let the piece tell you where to go.*" - Sharon Sandel

Piano Man

Carol A. Staub | 36" × 36" (91cm × 91cm) | collage on canvas (acrylics, hand-painted papers, gels, pencil, crackle paste, rubber stamps, black lava gel, natural sand)

I started this painting at a demo that I was giving. I was teaching how to use various mediums combined with paint and hand-painted papers. The real lesson was to just do it—be free and have fun. When you play is when your dreams are realized.

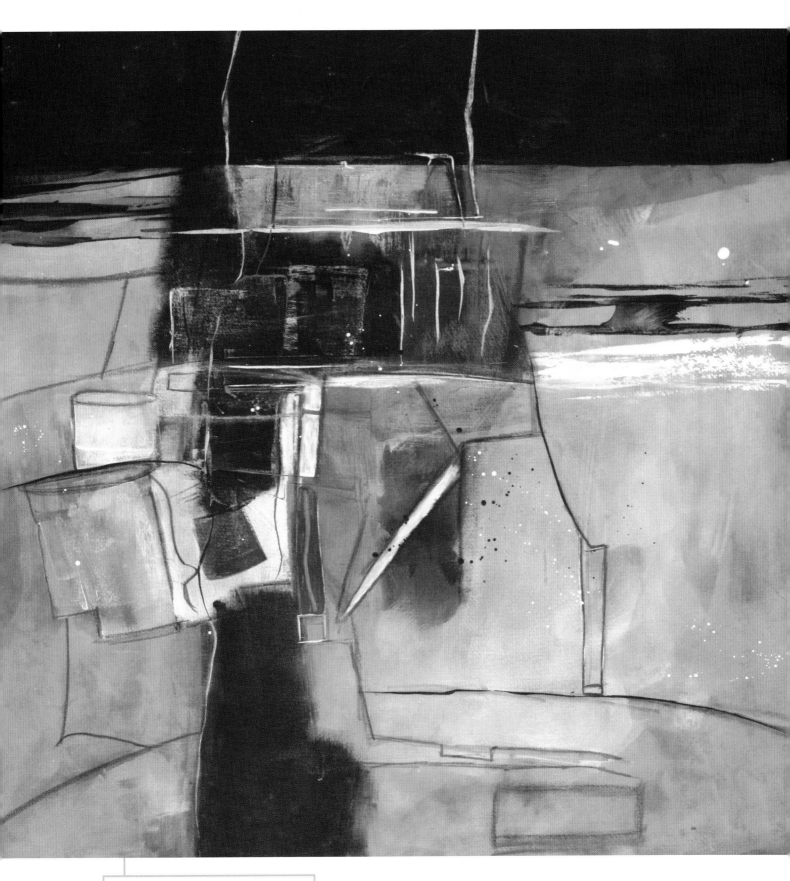

Sidewalk Series No.14

Carol A. Staub | 22" × 22" (56cm × 56cm) | acrylic, pencil on Aquarius 80-lb. (170gsm) watercolor paper

I'm a country gal, and the simple things in life often show through in my paintings. My *Sidewalk Series* is an example of just that. When I start a painting, I'm not necessarily thinking of doing a *Sidewalk* painting, but I guess my subconscious takes over, and when I'm finished, there it is. All those beautiful patterns I've seen in old sidewalks have a way of working themselves into some of my paintings. Could I be dreaming about them?

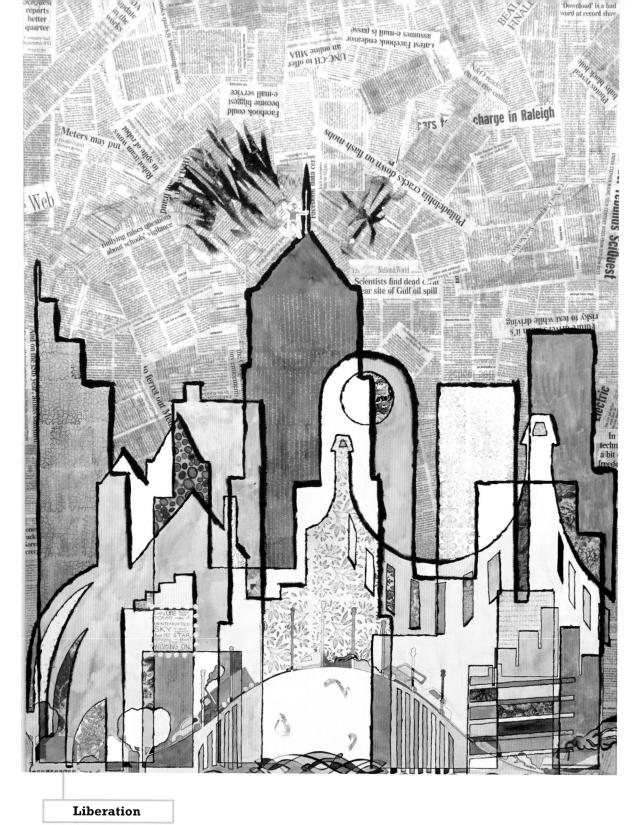

Liberation

Molly Cassidy | 46" × 34" (117cm × 86cm) | watercolor, acrylic on watercolor paper and birch with ink and permanent marker accents, newspaper and papers | photo courtesy of JP

With evolving technology, it's harder to get to a quiet, contemplative place for reflection. It's the new, for-better-or-worse challenge that we face, controlling the subtle insidiousness of it in our lives. The dream realized is mastering that constant presence to pursue life's mysteries. One continuous acrylic line of highly recognized skylines was used to represent this worldwide reality. The spaces created were ink stamped or fitted with patterned paper. Weeks of articles were glued down, and strips were peeled back to reveal the watercolor-and-salt technique of a starry sky. The quote provides the context.

" Stay true to the spirit of your idea, making the purity of your piece the first priority; don't let yourself get clouded by 'marketability' factors." • Molly Cassidy

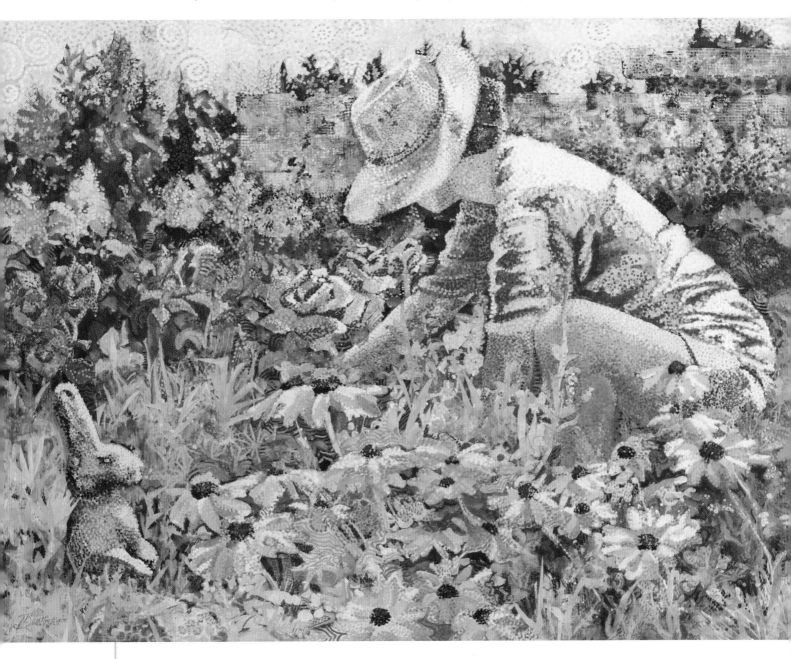

Jungle Management

Elise Meredith Beattie | 36" × 48" (91cm × 122cm) | collage (poured watercolors, acrylic paints and mediums with collage papers)

In *Jungle Management*, she sits in peace, mesmerized by her endeavors. So, too, the creative journey hypnotizes me and is the essence of happiness. The journey is my dream realized.

My painterly intention is to capture and marry the moment's spirit to the process. I begin by pouring paint, which imparts a sensation of swimming fearlessly with my subjects in a pool of vivid hues. Next I focus on strengthening the visual story. I dribble, splatter and collage the papers that I previously poured through to create a pattern-driven image that is a fusion of abstraction and representation. I work fearlessly so the layers of watercolor, acrylic and collage can bow to my imagination.

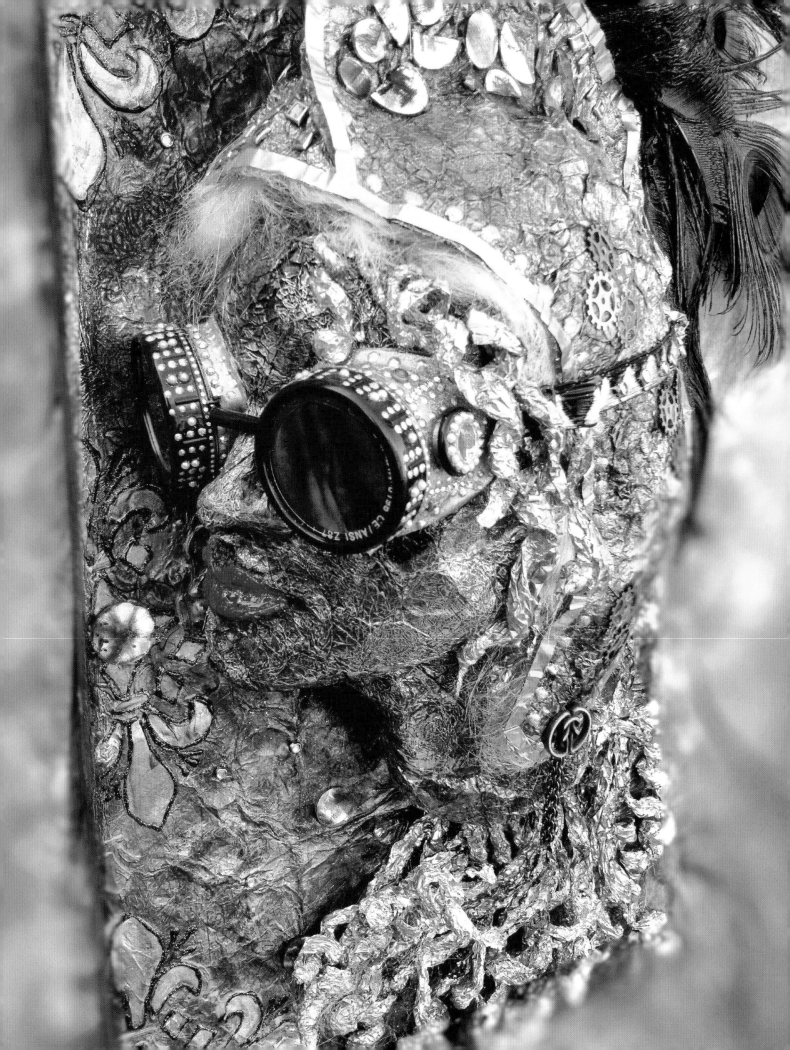

New Frontiers

Trying New Materials, Success With New Techniques, Taking Risks

Breaking out of one's comfort zone is never easy. Luckily, most of us are naturally curious, and it's this love of exploration that, in the end, gives us permission to try something new. The thrill of witnessing what appears just beyond the horizon when one is traveling down a road not previously traveled is what stokes the fires of many artists. As Lesley Riley puts it: "I like to do the impossible . . . you have to keep trying to do the thing you think you cannot do."

It can be easy to become attached to a particular style we've achieved—particularly if we believe others identify us with it. But I would suggest you have many more facets than the one currently reflected. When a new collage technique, a new combination of colors or a new tool used to scratch the surface is whispering to you, and you are tempted to try it, but afraid of not mastering it right away, remember the advice of Suzy "Pal" Powell: "Never be afraid to try something new or something you really want to do. It can't hurt you! It is just paper, paint, glue, etc."

Steam Punk Aviator

Brenda Abdoyan | 24" × 12" (61cm × 30cm) | foil, acrylic paint, found objects, peacock feathers, mirrors on stretched canvas

I love steampunk in all its forms, and I have held the image of the aviator in my head for years, just waiting for a method to properly express her. Finally I found it hidden in plain sight. For the *Steam Punk Aviator*, ordinary aluminum foil was used as the main sculpture medium. First the foil was creased and flattened many times to create a surface with a texture able to retain acrylic paint. The entire surface of the face was painted with flat black acrylic, and before it dried, the excess was wiped away, giving it a hammered steel appearance. Gold and bronze acrylic accents were applied for warmth and depth of character.

"Anything you can imagine, you can create. Maybe not today, but there is always tomorrow."

• Brenda Abdoyan

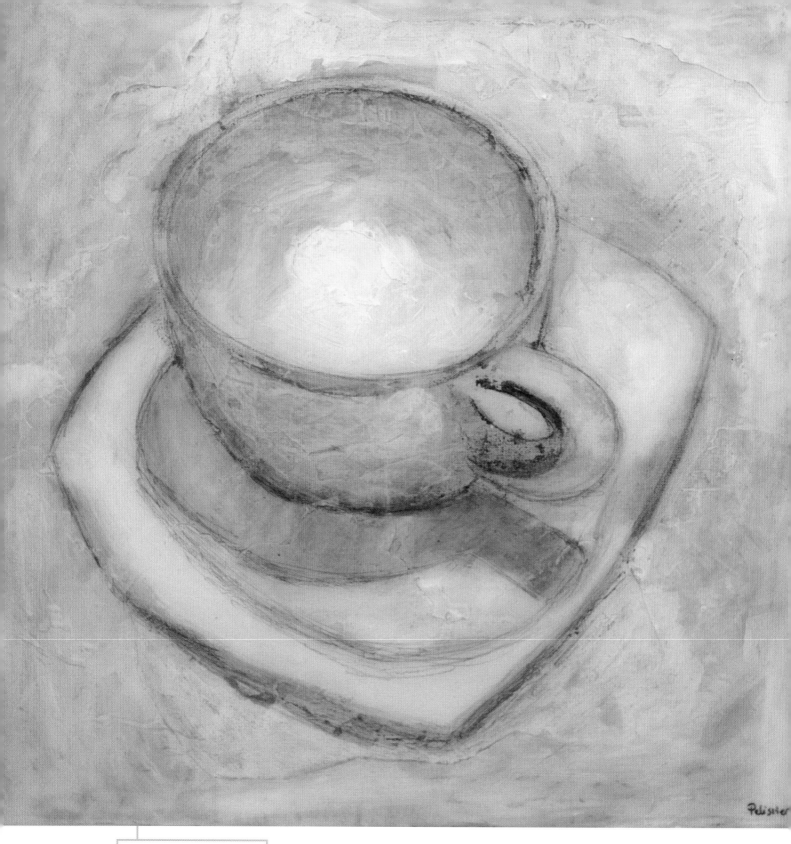

White Coffee

Sandrine Pelissier | 24" × 24" (61cm × 61cm) | collage, acrylic medium, acrylic paint, pastels, pencil, ink, epoxy resin

This painting started with the intent of incorporating more drawing in my paintings. So pencils and charcoal lines are very visible and an important part of the picture. I worked with a limited palette, mainly tones of blue, ocher/orange and white and kept the colors a bit subdued to convey an idea of softness and calm.

The painting surface is uneven; the painting process involved a lot of stages and layers with some scrubbing and sanding. These alterations on the surface are a nice contrast with the final layer of epoxy resin making the surface shiny and even again.

I associate the cup with the comfort of drinking a warm coffee or tea and taking some time for you, a break in your day.

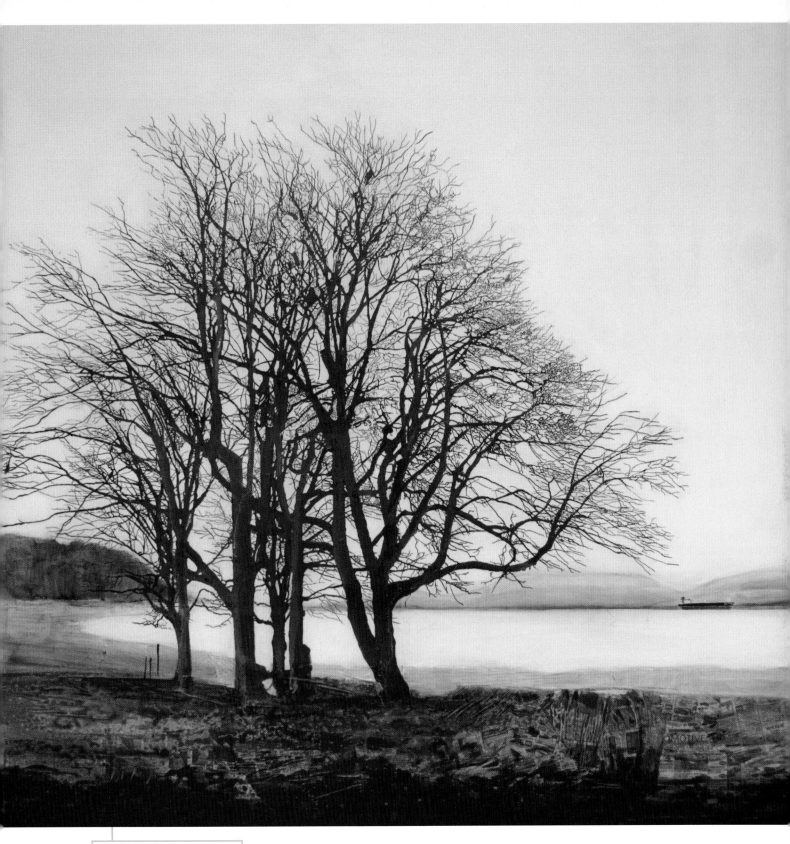

Recycling Life

Sandrine Pelissier | 48" × 48" (122cm × 122cm) | newspaper, pencil, acrylic medium, acrylic paint, India ink on canvas

With this painting, I wanted to show our connection with nature and how life is a big cycle. Most of the newspaper pieces I used for the ground were taken from the obituaries section, being careful to mask all personal information with paint and other clippings. The newspaper was made out of trees, and it has become the ground on the tree painting. Passed-away people are part of the ground where the tree is growing.

This painting was much more precise and detailed than what I usually do, but I enjoyed getting lost in the details of the intricate small branches. It was almost like meditating.

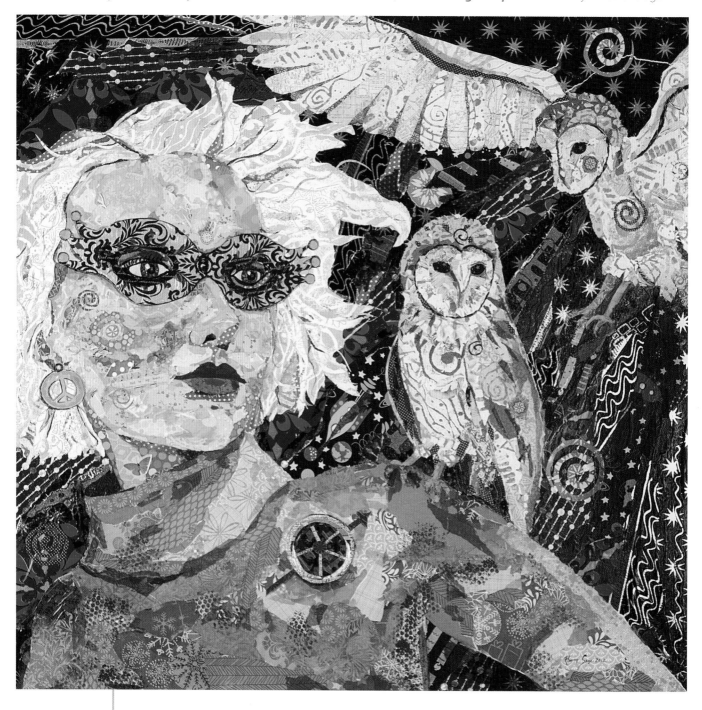

21st Century Athena

Raven Skye McDonough | 36" × 36" (91cm × 91cm) | paper on gallery-wrapped canvas

I developed the unique paper mosaic collage technique used for the creation of *21st Century Athena* over the last several years as the result of my curiosity and extensive experimentation. The bits of paper are collaged and layered on the canvas to create the image and tell the story. You could say I "paint" with paper! I can use as many as ten to twenty layers to create the effect I want.

My dream realized is having an undeniable and recognizable artistic style that is all my own. I have been working toward this goal for many, many years and feel this piece is the turning point in obtaining my dream.

❝To realize a dream, you must take imperfect action until you arrive at perfect results.❞ • Lesley Riley

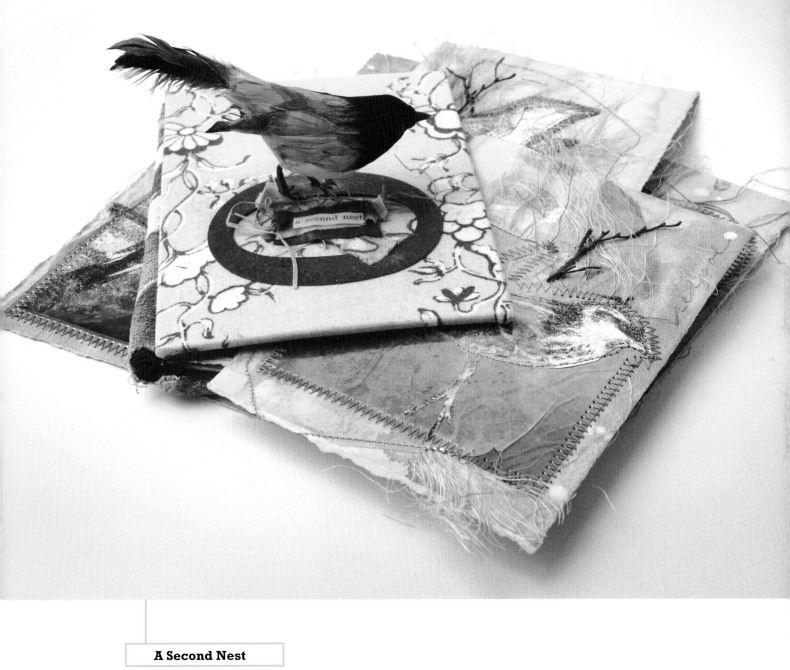

A Second Nest

Lesley Riley | 7" × 6" × 4" (18cm × 15cm × 10cm) | fabric, paper, canvas board, watercolor paper with stitched metal, mica, images, fibers, ephemera

I like to do the impossible. Stitch on metal? On mica? Combine disparate materials (hard and soft) into an ethereal whole? Dream realized!

Because I create on the edge, I'm not always successful. I have learned over the years that to be successful as an artist, you have to keep trying to do the thing you think you cannot do. There's no mama bird to push me out of the nest anymore. I have to push myself in order to discover how to use my wings. I once had a dream where I could fly. When I said to the voice in the dream, "But I don't know the way," she responded, "You will find it as you go." True, so true.

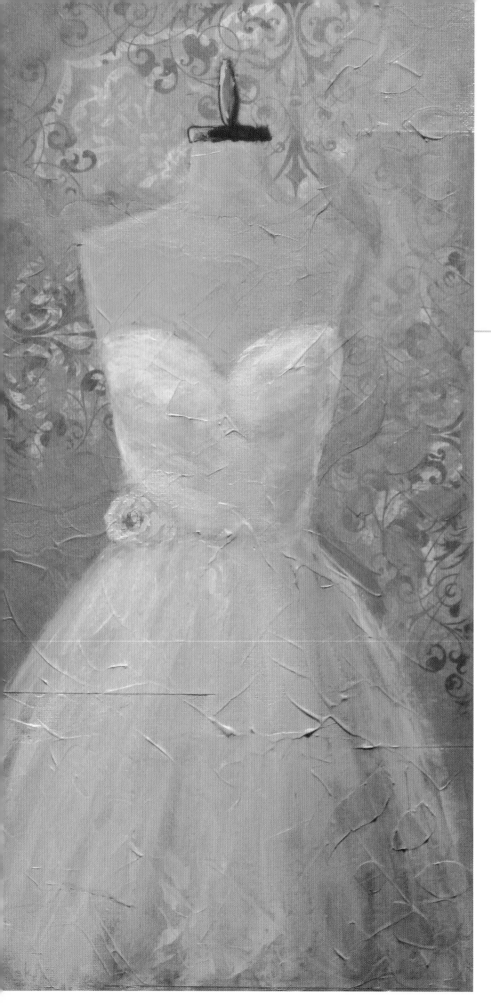

Wedding Gown

Barbara Pask | 20" × 10" (51cm × 25cm) | acrylic on gallery canvas

I am new to mixed media, and discovering what I could accomplish with these materials has filled me with such excitement for my work. My completed painting is exactly as I envisioned it.

The theme of *Wedding Gown* came from remembering how beautiful my daughter looked on her wedding day. Though this image was painted from my imagination, it is somewhat similar to her dress. My dreams were realized, and ideas for new projects are swimming in my head.

" First you need a definite vision of your desired outcome, and then fearlessly dive in and enjoy the journey." • Barbara Pask

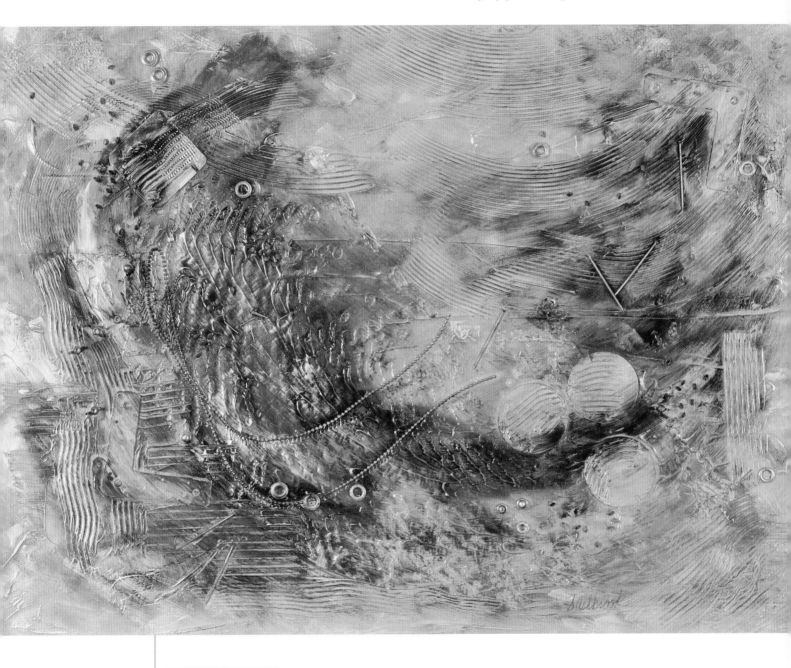

" *You are limited only by your imagination.* **"** • Susan Ashbrook

Imagination

Susan Ashbrook | 36" × 48" (91cm × 122cm) | acrylic mediums, acrylic paint, assorted hardware on canvas | photography by Marie-Louise Deruaz

For most of my life, I created ultrarealism in oils and acrylics. Eventually the wide array of acrylic mediums caught my attention, and after teaching others about them, I began to wonder why I was copying real life instead of exploring my own creativity with these wonderful products.

Imagination is one of the first pieces in my serious examination of acrylic mediums and mixed media—my backlash to realism. Suddenly the significance was the design, the color and the texture—not faithfulness to the original.

What a freeing moment that was! And shopping at the hardware store for art supplies and tools was very liberating. You just gotta try it!

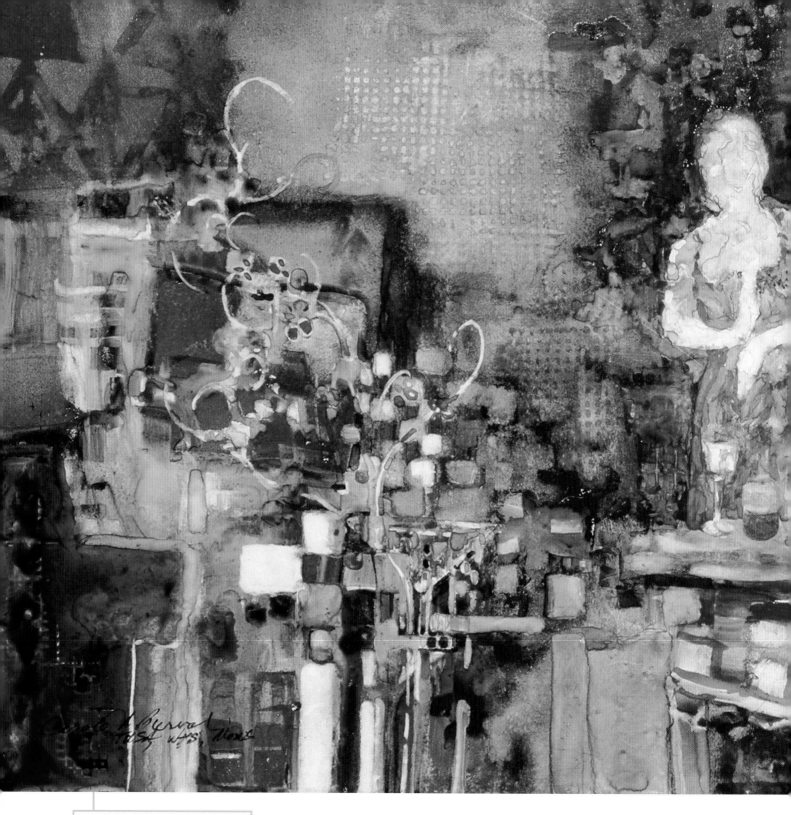

Faced with Reality

Carole A. Burval | 15" × 26" (38cm × 66cm) | transparent watercolor, iridescent/pearlescent watercolor (Daniel Smith) on Yupo surface

Faced with Reality was created during a major transition in my life.

Whom had I dreamt of becoming?

She appeared, faceless. Remember the quiet girl who only wanted to become an artist? I looked into the mirror, said a prayer and imagined it again.

I surrounded myself with flowers; I read, studied, listened to beautiful music, sipped wine and painted. I created and re-created myself through my artwork. Having discovered the freedom of painting on Yupo, I began. Willingly, the Yupo surface accommodated my continual modifications, giving me the freedom I craved throughout the painting process. Over weeks and months, the second figure (male) was slowly washed out of the design, the easel was covered with exquisite orchids, and the artist emerged and found her true self.

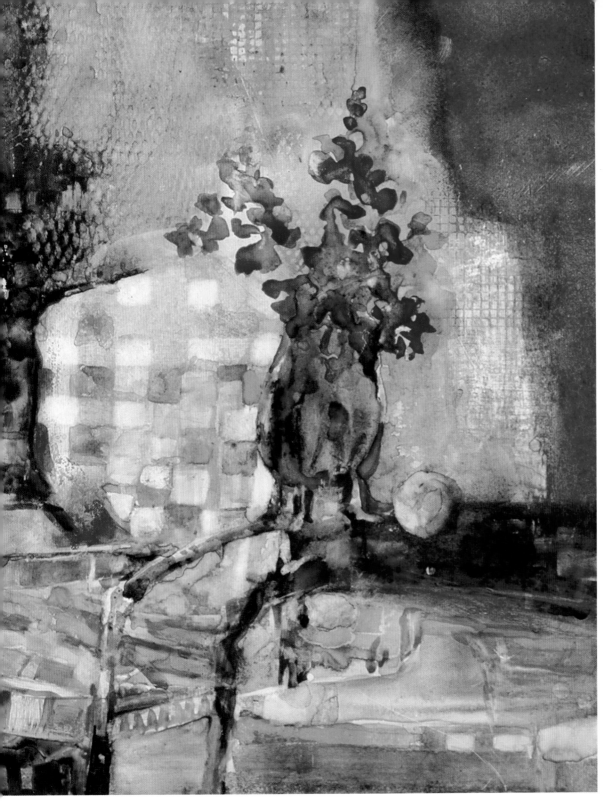

" 'Nana,' my four-year-old granddaughter says as she picks up the brushes, 'let's just make something beautiful.' And we begin." • Carole A. Burval

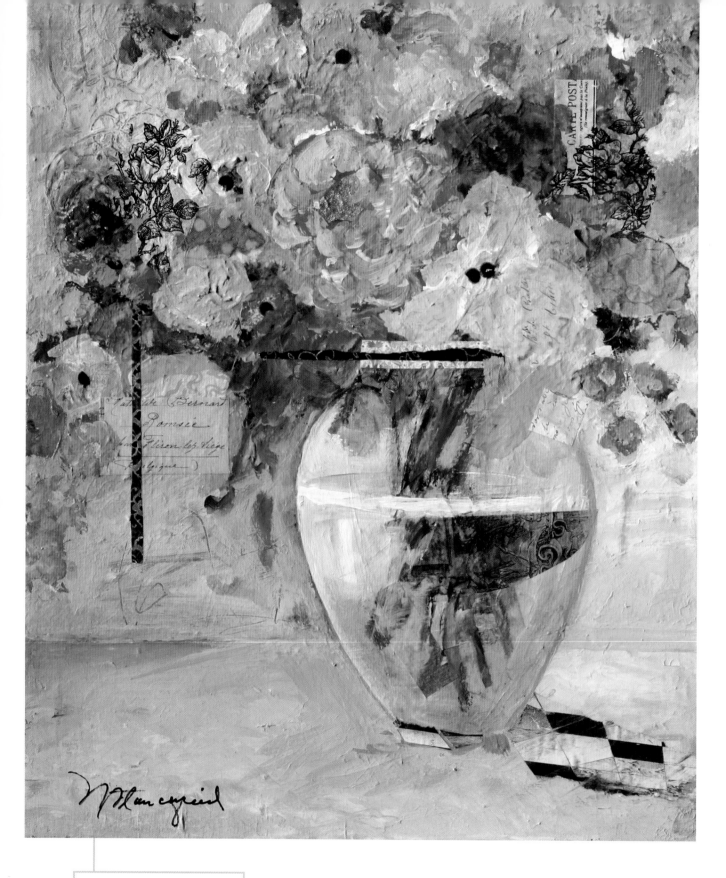

Blossoms on Blue

Nancy Stanchfield | 20" × 16" (51cm × 41cm) | collected papers, acrylic paint on canvas

I enjoy incorporating the playful element of collage into my paintings for the depth and texture it adds as well as for the element of surprise. *Blossoms on Blue* was taking itself too seriously until I began layering in the various papers. Then it was no longer just a vase of flowers. It became an exuberant, voluptuous cluster of color and pattern worthy of closer inspection. I find that keeping a strong sense of play in mind frees me to work spontaneously, intuitively letting the art unfold.

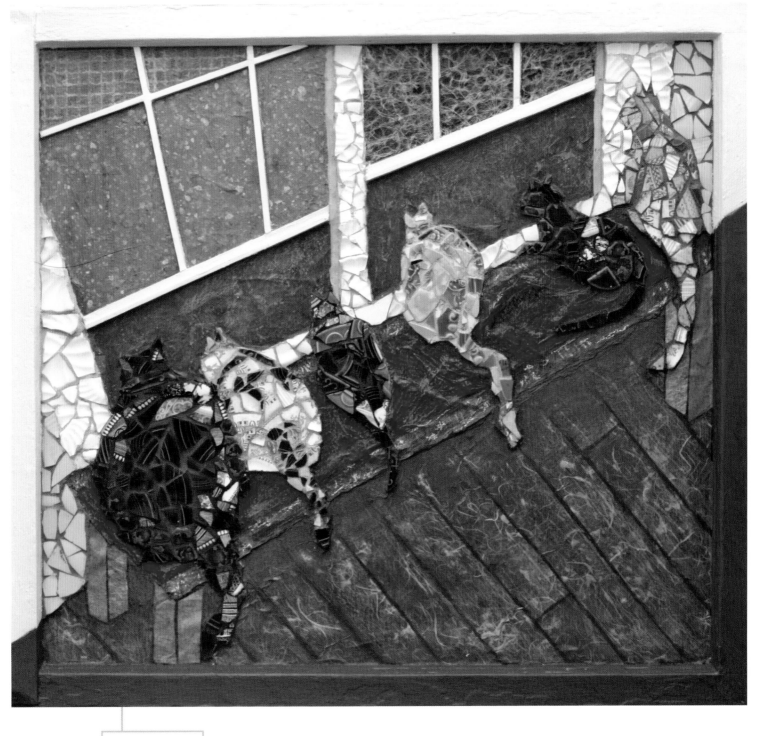

Cat TV

Elyse Marie Frederick | 30" × 32" (76cm × 81cm) | acrylic paint, oil pastel, colored pencil, paper, wood, glue, ceramic tiles and plates, fabric, grout on canvas

My friend Brian showed me a photo he called *Cat TV* featuring his four felines in a row looking out a window while sharing a comfy bench. The theme and perspective were intriguing, an irresistible inspiration for a new piece of art. The scene reflected the wonder of being entertained by simply taking time to observe the world. My dream was to capture, as a gift to my friend, that same essence and ability of being interested in life.

While I worked on the piece, his furry family grew to six cats, complicating my idealized plan. The challenge to fit an increased audience in my once-perfect composition actually added to the uniqueness of the scene. My experimental process also evolved as I combined different mediums and techniques to achieve the effect I wanted; each medium had its own personality to convey and contribute to a distinct "family" of mixed media. Previously I had kept mediums separate, but the unexpected additions forced me to work in a new way. It seemed adapting artistically to Brian's adoptions had influenced my creative process in a positive manner! I was thankfully reminded that my dreams can be unplanned, even with the best intentions.

"To be an artist is a life quest. Accept challenges and fear nothing. You will be fulfilled." · Grace M. Rankin

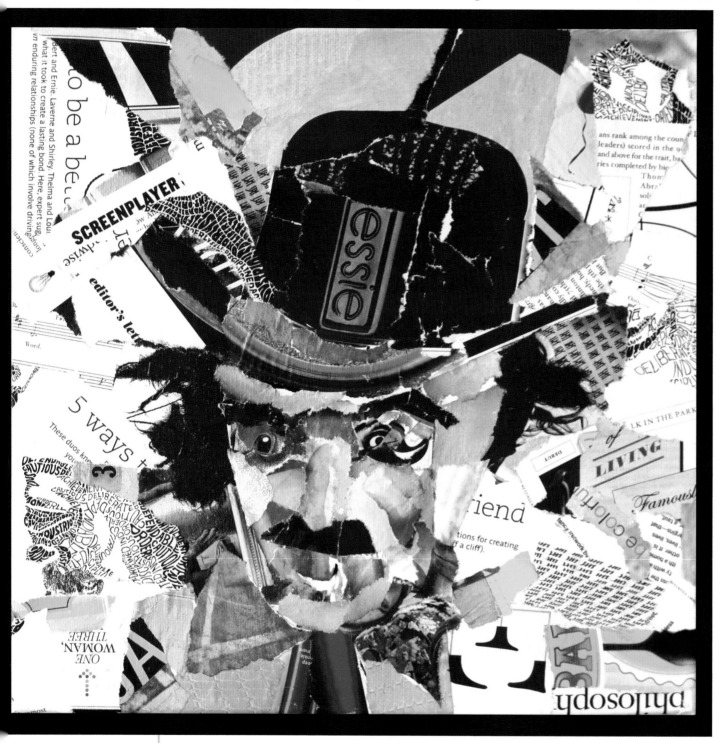

Charlie

Grace M. Rankin | 12" × 12" (30cm × 30cm) | torn paper on canvas

I often use collage in my watercolor work in various ways, but I was excited to see a new technique being done, using only torn paper and matte medium.

Our town of Niles was where the iconic Charlie Chaplin made silent films and is honored in June each year, so the subject seemed just right.

Our painting group was in need of inspiration, so I suggested a Charlie collage challenge. My joy is to find new approaches and to share with others. This was a hit!

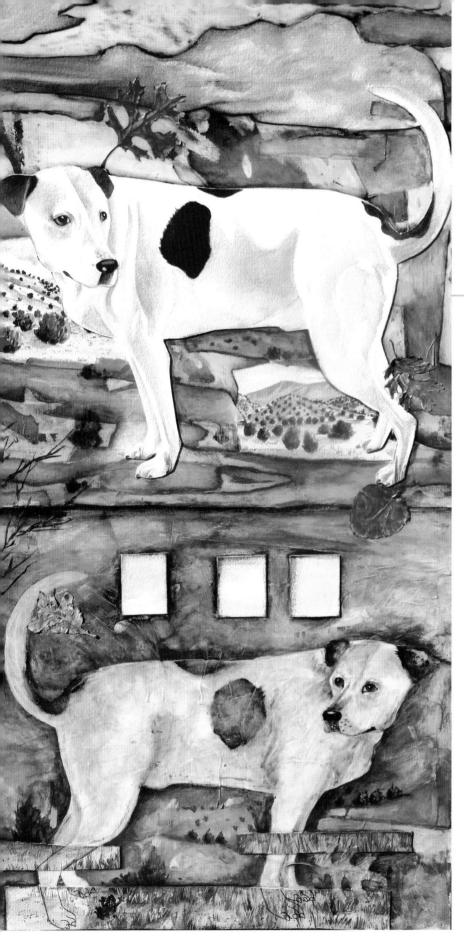

Transformation

Kathy Brandenberger-O'Rourke | 36" × 24" (91cm × 61cm)
watercolor, acrylic paint, paper, glue on Masonite

My dog Zack inspires me. He has become my muse because he has a great personality, but I never paint portraits of him. He becomes part of a composition and is usually placed in improbable situations.

This particular piece evolved from an unfinished watercolor of Zack and cut or torn sections from old watercolor paintings. I poured Elmer's Glue in certain areas on Masonite and then covered it with various sizes of torn paper. I then let the glue dry overnight, stained it with color and added the watercolor pieces as well as a few leaves.

My favorite element of this composition is the combination of the translucency of the glue and the addition of the watercolor sections. Even though it was a planned composition, I like the spontaneity of interesting marks that invariably occur when creating a piece of art. The mixed-media experience is one of discovery, finding materials that work together to create the initial vision of an idea.

Anchors Aweigh

Suzy "Pal" Powell | 24" × 12" (61cm × 30cm) | torn
magazine paper, gloss medium on canvas

I have a forty-four-year-old newspaper
clipping of my husband at an airport
playing for a battalion leaving for
Vietnam. After enlarging it, I drew it with
a permanent marker on a stretched
canvas. It was created from pages torn
out of magazines. I use the colors, text
and textures as my palette, gluing them
down with Liquitex gloss medium. It is
varnished with Liquitex varnish when
completely dry. It is unbelievable what
you can find in a magazine.

My dream was to really portray and
preserve those four years of his life and
what it meant.

*"Never be afraid to try something
new or something you really want
to do. It can't hurt you! It is just
paper, paint, glue, etc."*
• Suzy "Pal" Powell

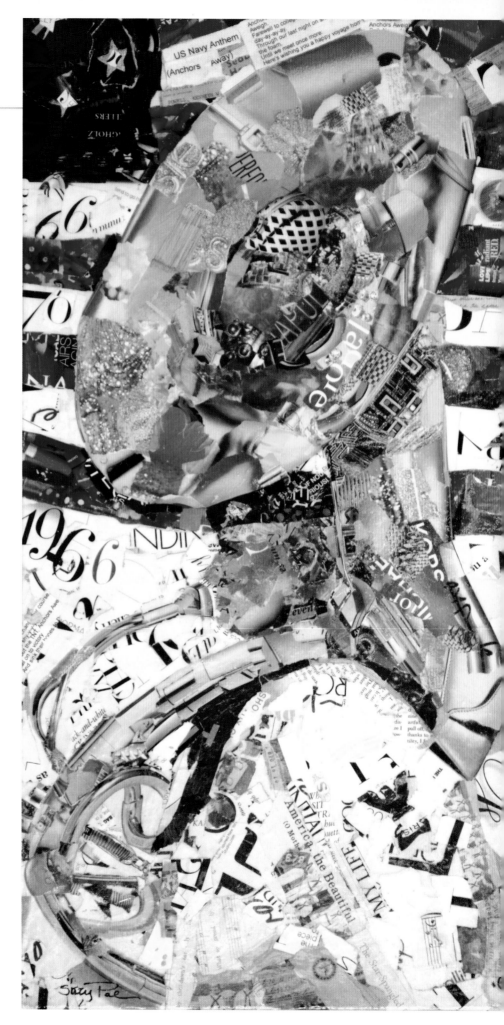

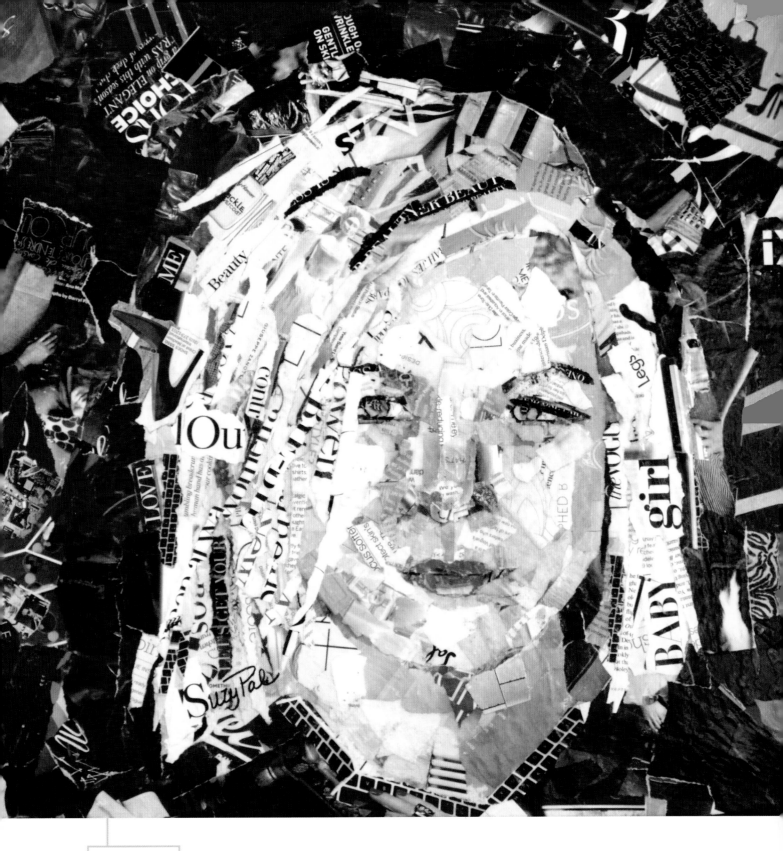

Karla

Suzy "Pal" Powell | 18" × 18" (46cm × 46cm) | torn magazine paper, gloss medium on canvas

Karla is my eighteen-year-old granddaughter, and my dream was realized when she saw the collage and asked me *when* she could have it to hang in her room, and also when our friends saw it and automatically knew who it was!

When I first did this, it didn't look like her at all, so I completely redrew it and started over, on top of what I had, measuring each part of her face. There is a lot of personal stuff in the collage about her, which was fun to add.

True Colors

Lisa Renner | 6" × 5" (15cm × 13cm) | polymer clay, chalk pastels, acrylic paint, metallic and alcohol ink

When I begin a new piece of art, I surround myself with a cache of favored materials, including polymer clay, alcohol inks and patinas. These resources not only offer flexible creative leeway, but also provide an anticipated element of discovery that motivates and surprises me.

With regard to figurative sculpture, my affinity for odd color applications and peculiar body styles that veer away from the traditional doll figure prevails in my work and are represented in this piece.

True Colors is titled after a project I was part of several years ago that exposed us all to the influence of color relationships. My color combination for that project was blue and ochre, which I chose randomly at that time, only to be energized by it for years to come.

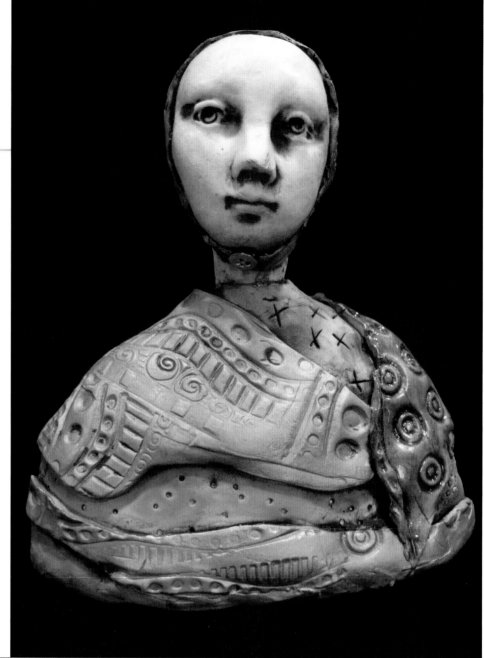

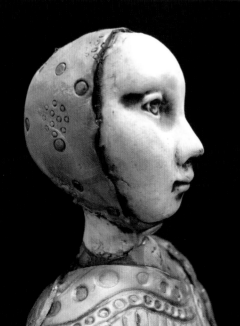

" I experience a sense of accomplishment when I complete a work, but it is the perpetual love of the creative process that drives my artistic growth." · Lisa Renner

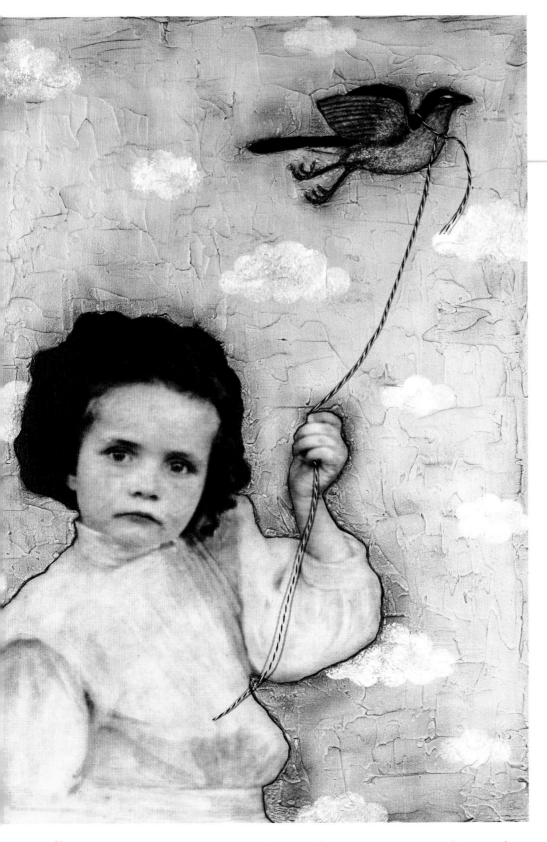

Aloft

Stephanie Jones Rubiano | 24" × 18"
(61cm × 46cm) | paper, pastels, pencil, plaster, acrylic
on hard panel

Sometimes another person has to gently point out your dreams to you. I am a mixed-media artist who is drawn to objects from previous eras, carefully working them into intricate assemblages under 12 inches (30cm). My husband had an image of an assemblage printed on a large canvas so I could finally see what he was encouraging me to try. I realized that I wanted to work in a large format but had been quite daunted by the thought.

Once I began working large, I found I enjoyed the freedom and the excitement that came with working with new media, such as plaster and acrylics. Forcing myself to try a new direction fed my creative fires and helped me grow as an artist.

" Until you try the things that might intimidate you, you cannot discover the new joys and dreams that are on the other side of that intimidation." · Stephanie Jones Rubiano

"Dream your dreams with confidence and never be afraid to take the first steps toward discovering your own 'path of light.'" • Karlyn Holman

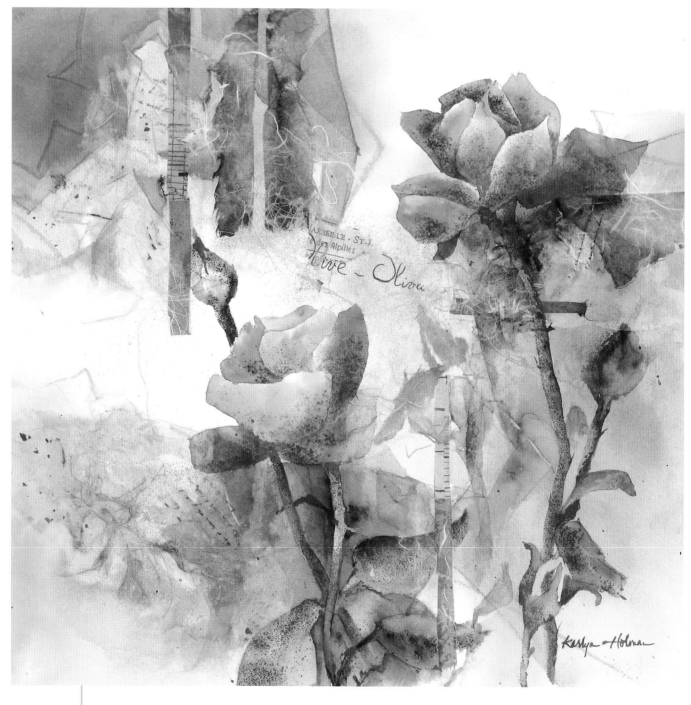

Path of Light

Karlyn Holman | 15" × 15" (38cm × 38cm) | transparent watercolor, watercolor pencil shavings, collage papers (chiri, ogura, Thai white unryu, dressmaker's patterns, toned tissue paper) on 140-lb. (300gsm) Arches cold-pressed bright white paper

This painting was the first in a series of paintings with a path of light in the background. Spontaneity and intuition played a big role in the design as I painted the piece with quick and energetic strokes and tried my best to preserve a sense of directness and simplicity.

My plan was to create the contrast of a white path of light behind the dark flowers and to develop and enrich the painting with found collage. Because I am very passionate about mixing media, I played with the textural addition of found papers and watercolor pencil shavings to bring a new reality to the work that could not have been accomplished by any other means.

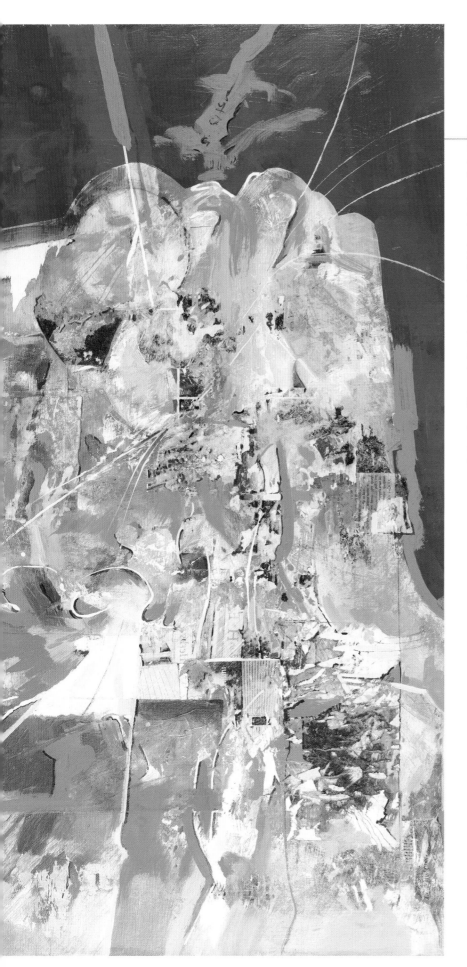

Encore

Mel Grunau | 32" × 16" (81cm × 41cm) | acrylic, collage, enamel on wood panel

I have painted many pictures and done demonstrations using floral collage items and acrylic paint. Usually the more time spent, the better the result. At the end of one five-hour floral collage workshop, my painting had not produced a good result, and I told the participants, "I think I'll go home and hit this with my belt sander." I did exactly that—revised my original plan and continued to expand the painting as an abstract.

After hours of working on small details, I masked off a section and sprayed the remainder with red enamel. When I try something new and it works, it truly is a dream realized.

"*When pursuing your dream, don't be afraid to experiment. Try something new. You may be pleasantly surprised.*"
• Mel Grunau

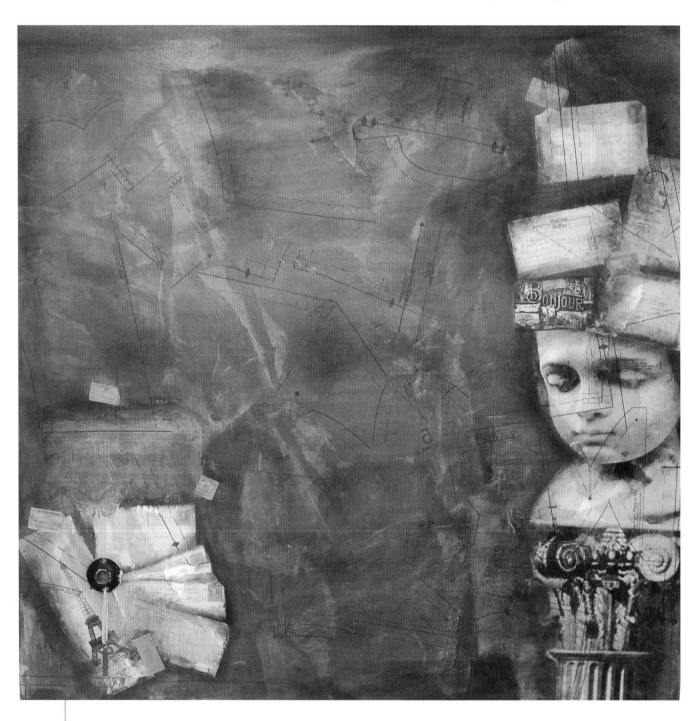

Memories of Paris

Jenny Manno | 36" × 36" (91cm × 91cm) | acrylic on finished canvas, antique hardware, vintage sewing pattern paper

I was an art snob, if you will. Growing up I always felt if a piece wasn't done realistically, I had no appreciation for it. I always thought that it wasn't "real" art. That was, until I took my first mixed-media workshop almost thirteen years ago.

My eyes were opened to a whole new world of color, textile, imagery . . . the list goes on and on. I was exposed to a new way to tell a story. The freedom for an artist who creates a mixed-media piece is boundless.

Memories of Paris is and always has been one of my favorites. For me it inspires beauty and the "what if" in the story.

"Remember, doing art is never a waste of time even if it doesn't turn out as you desire. As you work, you enrich your creative soul and take a few more steps toward realizing your artistic dream." • Gayle Gerson

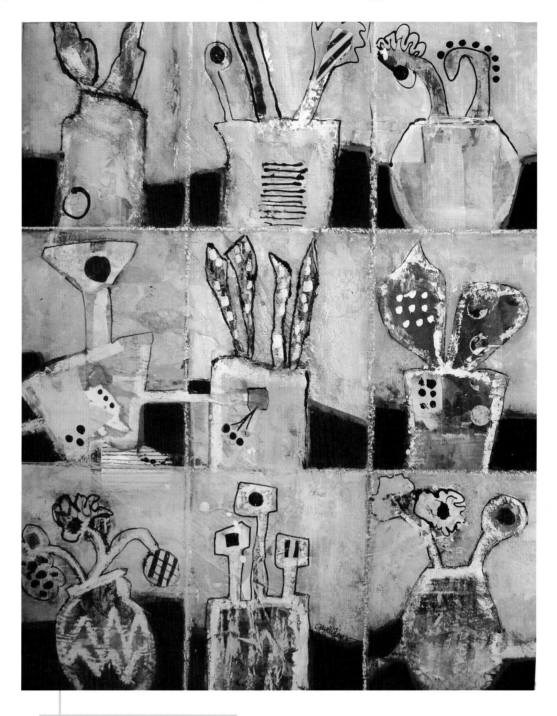

Three Martini Lunch

Gayle Gerson | 26" × 20" (66cm × 51cm) | water media, ink, oil pastel, collage papers on watercolor paper

This piece represents my realization of the long-sought dream of any artist: developing an exciting and innovative way to begin a work of art. It began with a challenge given by our local collage society to create something pleasing using just black, white and gray.

I started by adhering a random accumulation of black and white collage pieces to a sheet of watercolor paper. It was chaos, which I proceeded to rein in using a grid design.

Gradually those alien-looking potted plants emerged as I worked. Now I am comfortable with beginning a work by creating a chaos of images and meanings with collage, and (if I am lucky) bringing it to a successful and artful conclusion. The title refers to one of those wonky images that looks like a martini glass with an olive in it.

> *"Limit your choices so you must come up with some new combinations resulting in creative breakthroughs in your art."* · Myrna Wacknov

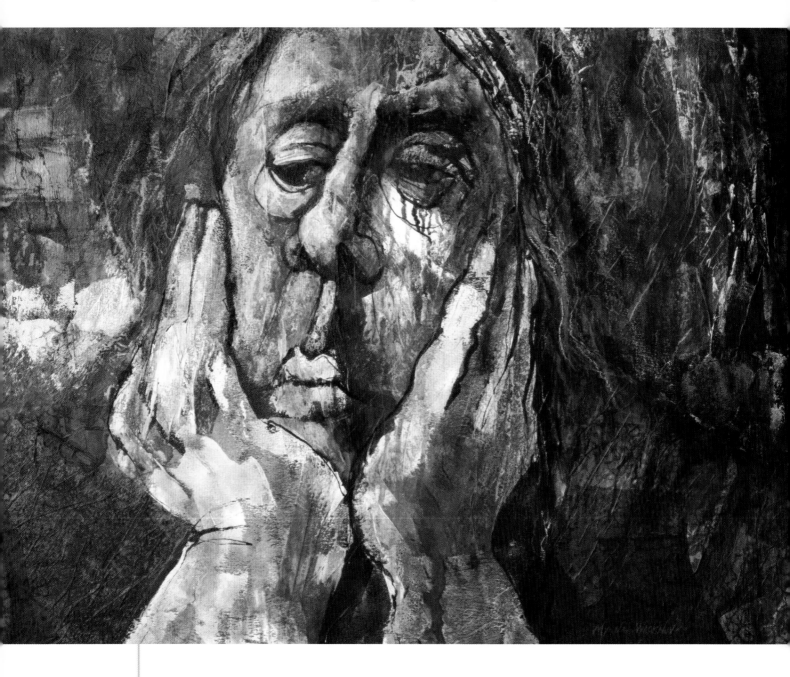

Home Alone

Myrna Wacknov | 22" × 30" (56cm × 76cm) | acrylic, gesso, collage, ink, watercolor crayons on watercolor paper

Home Alone came about because of my desire to get beyond simply copying a photograph. I started out drawing an accurate line drawing from a photograph of myself. Looking at the first drawing, I did a second drawing.

With the goal of simplifying each time, I drew four more times from each previous image. The result was a very stylized portrait, which I found strangely appealing. I combined this image with an experimental mixed-media process from a new book I had just purchased. The result was nothing like any image in that book or any image I had ever painted. Dream realized!

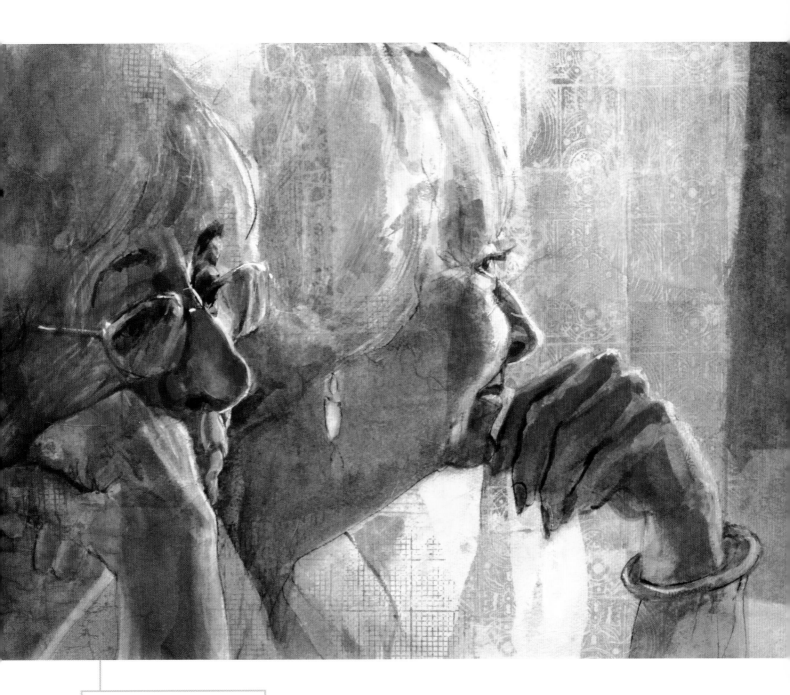

What About Evelin

Myrna Wacknov | 18" × 24" (46cm × 61cm) | watercolor, gesso, hand-painted tissue on watercolor paper

I am a very literal artist. I paint what I see. I longed to be more creative and inventive but was at a loss at how to "see" differently. My breakthrough came in a workshop that focused on the elements of design, keeping to one image and creating a series of twenty different paintings.

While developing a whole new approach to my art, I discovered that I was most passionate about the elements of line and texture.

I now explore the endless combinations of textural techniques with drawing and painting. Fulfilling another dream, I am able to pay it forward by sharing my ideas through workshops around the country.

"Begin with the basic fundamentals of design in your painting. Allow the painting to tell you where it wants to go." · Sarah E. Alexander

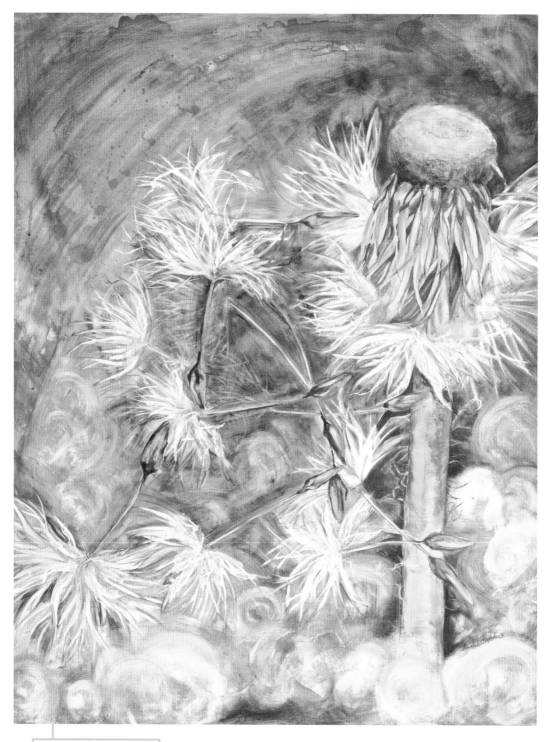

Letting Go

Sarah E. Alexander | 40" × 30" (102cm × 76cm) | watercolor, paper on watercolor canvas

After undergoing multiple eye surgeries (eleven) for Grave's eye disease, I was housebound and struggling with double vision. This forced me to approach my painting differently. I began to work much larger and looser than I had done previously. I began to look closer and zoom in on my subjects. Frustrated by the limitations of watercolor paper, I experimented with alternative watercolor surfaces and by collaging with handmade papers.

The depiction of dandelions was exciting to me, both texturally and symbolically. The subject was ideal for my new expressive textural style, allowing me to show movement and stillness at the same time.

Journey

Laura Lein-Svencner | 36" × 36" (91cm × 91cm) | collage on canvas

Taking a yearlong study on composition in smaller works, I expanded to a larger format setting out to complete twelve canvases 36" × 36" (91cm × 91cm).

This piece is about the process of combining sources and working through my own personal life experiences and ideas. Making my collage papers rich in color and visual texture to mirror life around me, I moved toward the unknown, trusting in the outcome. Using intuition as a guide and pulling only from the past, my trail is laid out. Now all I have to do is follow it.

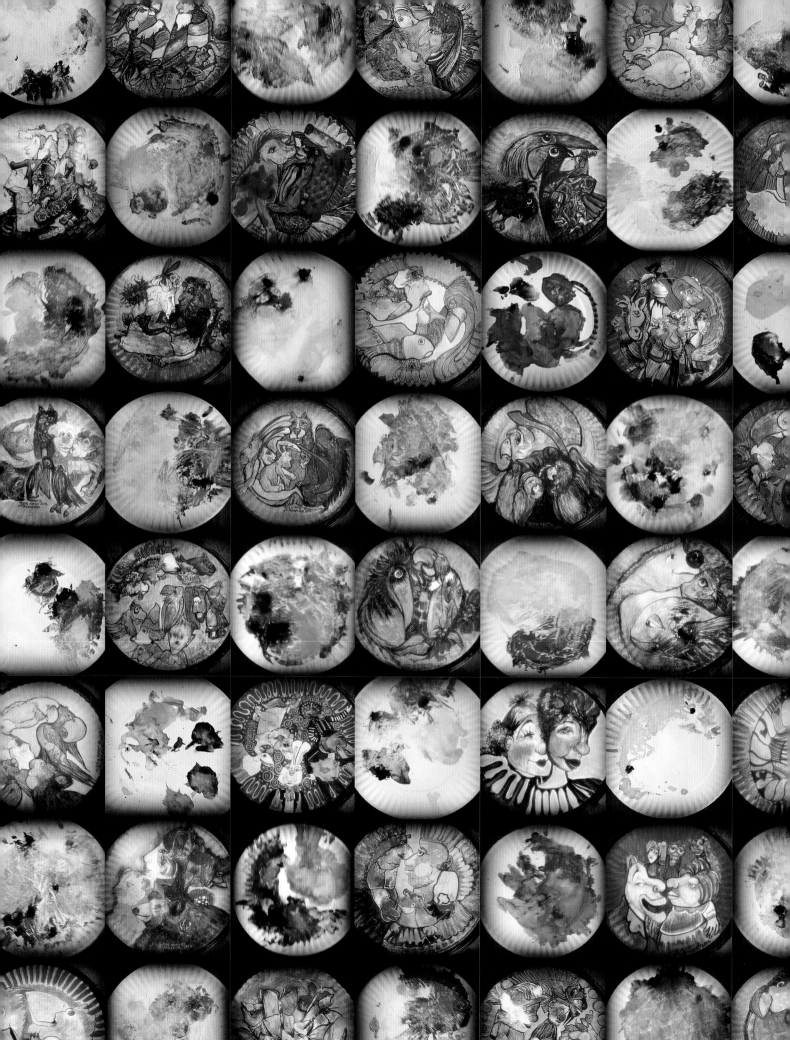

Rising to the Challenge

Creative Problem Solving, Experienced Growth, Overcoming Suffering

Overcoming challenges—whether resurrecting artworks we thought were ruined or using art as therapy to work through issues in our personal lives—each of us is more capable, more resilient than we might realize. Aleta Jacobson has had to overcome challenge, but as she puts it, "Now I reclaim, refurbish, 'scratch' at the rust to achieve something that never died, but was merely concealed."

By being willing to take risks and to make mistakes, we acquire new skills and often find happy accidents in the process. TJ Goerlitz says, "The quality of my work is in direct proportion to my willingness to completely screw it up."

And at the end of the day, as Eileen F. Sorg reminds us, a little optimism goes a long way. Her work, *The Power of Self Esteem*, is her "homage to everyone (myself included) who has ever felt small in the face of an imposing challenge."

"*Immersing myself in the creative process became an anchor for me to face the unknown. I believe to face our doubts and insecurities is part of pursuing our dreams.*" • Lisa Agaran

28 Plates, Before and After

Beth Keitt Brubaker | 9" (23cm) | paper plates, watercolor, mixed media

These were twenty-eight paper plates used as painting palettes for a watercolor class that were going to be thrown away—discarded, as if they no longer served a purpose. Yet I saw a beginning in each plate. Each plate had a story. Some had only a spot or a stain of color; others, many colors—warm or cool, monochromatic, analogous or complementary. There were all kinds of shades, shapes and forms, lights and darks— even the plates themselves with their design and structure.

Learning to see what is and is not there, the positive and the negative—it was all there in those plates. Everyone sees things differently. I found that I see faces—in everything. The faces are always different—individual images interacting with each other, telling a story. These plates have opened up worlds of infinite possibilities for me, and I have found my style and purpose for telling the story of these characters.

"Do not be afraid to use what talents you possess; the woods would be very silent if no birds sang except those who sang best." • Henry van Dyke

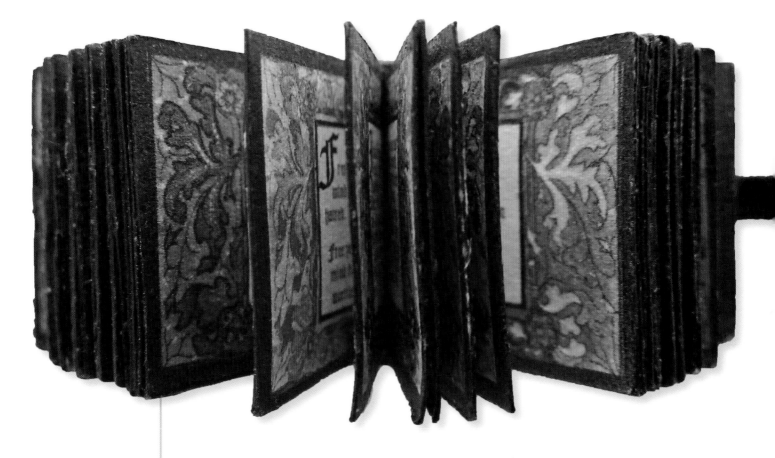

Quotes for Life

Joy Bathie | ¾" × ¾" × ½" (2cm × 2cm × 1cm) | bathroom tissue, gel medium, impasto medium, rubber stamp, acrylic paints, tea-stained paper for the pages, kangaroo leather, brass bead, Canon inkjet inks, small wooden box, Modern Masters Metal Effects, Styrofoam, black velvet, walnut ink, shellac

I never had the confidence to attempt bookbinding until I attended a workshop several years ago where I created an encouragingly professional-looking journal. From that humble beginning, I progressed to creating a variety of artists' books, each bringing a greater sense of achievement. But there was a special book I truly thought I would never be able to make: a miniature. To my delight, this year I achieved my dream, and here is the result.

The book's "leather" cover was created from layered and heavily embossed bathroom tissue and gel medium, sealed and antiqued with Yellow Ochre and Raw Umber acrylic paints, walnut ink and shellac. The closure is a narrow black kangaroo leather strap, looped over a tiny brass bead; the spine is also covered with kangaroo leather.

Inside, one hundred pages are perfect bound, because sewn signatures would be far too bulky. Apart from the title page and colophon, the pages contain quotations printed in Old English Gothic text surrounded by richly colored medieval illuminated borders.

The tiny medieval-style book is nestled in a small box lined with black velvet. The box lid was textured by embossing into impasto medium with a rubber stamp. When dry, this was then rusted and aged, giving the appearance of having lain buried for centuries.

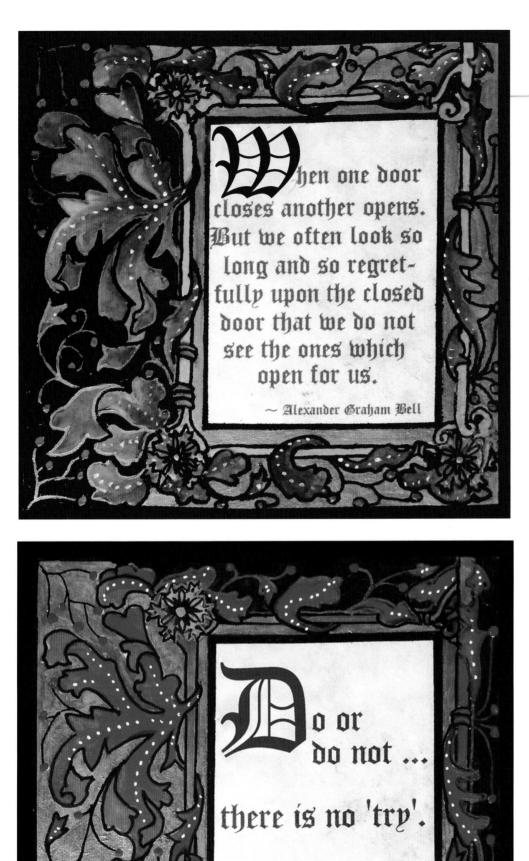

Quotes for Life

Joy Bathie | ¾" × ¾" × ½" (2cm × 2cm × 1cm) |
bathroom tissue, gel medium, impasto medium, rubber
stamp, acrylic paints, tea-stained paper for the pages,
kangaroo leather, brass bead, Canon inkjet inks, small
wooden box, Modern Masters Metal Effects, Styrofoam,
black velvet, walnut ink, shellac

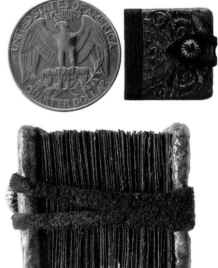

The Power of Self Esteem

Eileen F. Sorg | 19" × 21" (48cm × 53cm) | colored pencil, ink, transparent watercolor on Arches 140-lb. (300gsm) hot-pressed watercolor paper

The Power of Self Esteem is really just a modern take on the old story of David and Goliath. It is my homage to everyone (myself included) who has ever felt small in the face of an imposing challenge and how having a positive attitude can really carry you through those situations.

Red Meal Ticket

Jenny Manno | 36" × 48" (91cm × 122cm) | acrylic on finished canvas, antique hardware, vintage sewing pattern paper

Red Meal Ticket is such a strong piece. During this time in my life, this piece needed to be made and it had to be strong in its storytelling. With this piece, my hopes were to have the viewer feel the hardship and to sense the struggles brought on by humankind within the monotony of day-to-day life.

My favorite medium to work in is acrylic. It can constantly be manipulated and adapts well with all types of mediums. I also love to work with old hardware. "Beautiful decay" is what I like to call it; the older and rustier, the better.

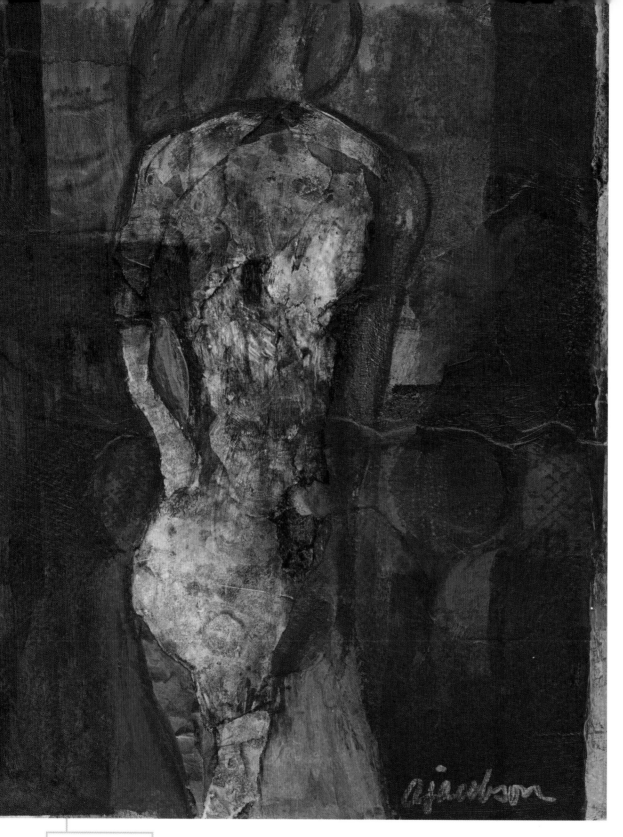

Leaving

Aleta Jacobson | 10" × 7" (25cm × 18cm) | acrylic, watercolor-stained paper, watercolor pencil on gessoed 140-lb. (300gsm) cold-pressed watercolor paper

This piece is about leaving a bad situation, bruised and battered; leaving one dream and changing what is not working. Crafting this figure became frustrating. I tore papers that I had stained with acrylics and watercolors to form some shapes around the figure, then unified the painting with the deep purple to change the feeling.

As an artistic person from the beginning, I was forced to leave my dream of creating art for the stability of a job. After a life-changing auto accident, I had the freedom to return to my dream. I went back to the classroom to refresh my art. When the classroom became too restrictive, I left for the freedom to create what comes from my heart. Now I reclaim, refurbish, "scratch" at the rust to achieve something that never died, but was merely concealed.

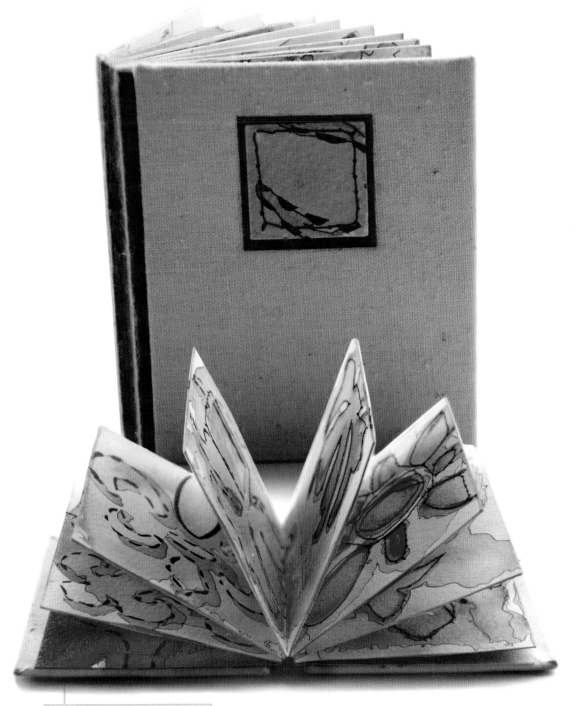

> *"The quality of my work is in direct proportion to my willingness to completely screw it up."* • Tari "TJ" Goerlitz

Call and Answer

Tari "TJ" Goerlitz | 4" × 3" (10cm × 8cm) | watercolor, machine- and hand-stitching

This sixteen-page drum-leaf artist's book represents my dream of a chance for further learning. For many years while living in Germany, I worked alone in my private studio. My main connection to the mixed-media world was through the Internet and my blog, Studio Mailbox. I was limited in hands-on support and was constantly challenged to solve technical issues on my own. Because sewing is a large component of my work, I was often frustrated when my stitches would affect the back sides of my journal pages.

After relocating to the United States, I was accepted to the Artist's Cooperative at the Minnesota Center for Book Arts. One year (and many classes) later, I have gained a solid understanding of many binding techniques and book structures. This piece was my first success at hiding the back side of my stitched artwork since a drum-leaf structure comes together by adhering the back sides of each spread.

The air is still in dreams
a clear and plasmic element.
No ripples dim the surface as she falls
the cold distress
of days unknown of days to be.

The lake receives her, the lake her lover.
Her ravished flesh redeems the rocky floor.
Still, as if asleep, she lies
a treasure to be salvaged *by who dares*
shatter the level mirror of the lake.

Lake of Dreams

Lisa Agaran | 12" × 12" (30cm × 30cm) | acrylic, collage, found objects on board

This piece materialized during a time when I was beginning to define my unique artistic voice and myself as a "real" artist. When I made the decision to get serious and pursue an art career, I was faced with a lot of uncertainty. Immersing myself in the creative process became an anchor for me to face the unknown. I believe to face our doubts and insecurities is part of pursuing our dreams and essential to having our dreams realized.

Wide River

Laura Lein-Svencner | 36" × 36" (91cm × 91cm) | collage on canvas

Following a creative path involves choices: opportunities, risk-taking, expanding, contracting and, to some extremes, life and death. It's knowing when to paddle or when to hang on for dear life. Making choices or facing new opportunities can feel like a frozen edge of fear, but with courage, the creative life force can flow. Being able to create this kind of drama on any given surface mimics all the same life experiences we ride out and accomplish in our own lives.

> *" Inspiration is for amateurs—the rest of us just show up and get to work. Every great idea I've ever had grew out of work itself. "* • Chuck Close

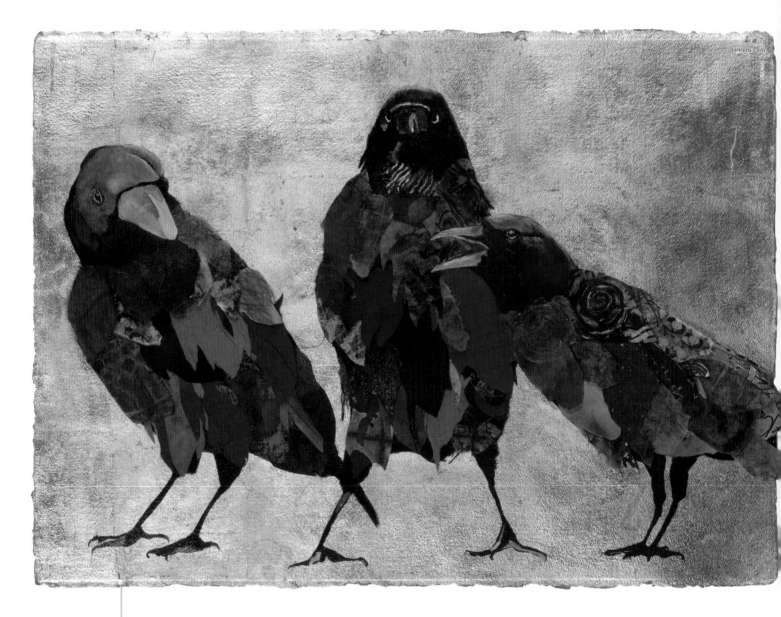

Breed Crows (Cria Cuervos)

Rosa Ines Vera | 23" × 30" (58cm × 76cm) | watercolor, acrylic, gold leaf, printed papers, stamped and printed fabrics on 300-lb. (640gsm) cold-pressed watercolor paper

Breed Crows is the fourth in a series that was inspired originally by a medieval Spanish proverb. I found at first that working on pieces that reflected my concern with family issues was therapeutic. As the pieces evolved, the crows began to develop their own personalities and relationships with each other.

To start, I coated a piece of watercolor paper with special sizing and glued down the individual gold leaves. I then drew the crows on tracing paper, cut them out and placed them in different places on the paper. Once they were "talking" to each other, I painted them in and attached the cloth and paper feathers to the surface with glue and fusible web.

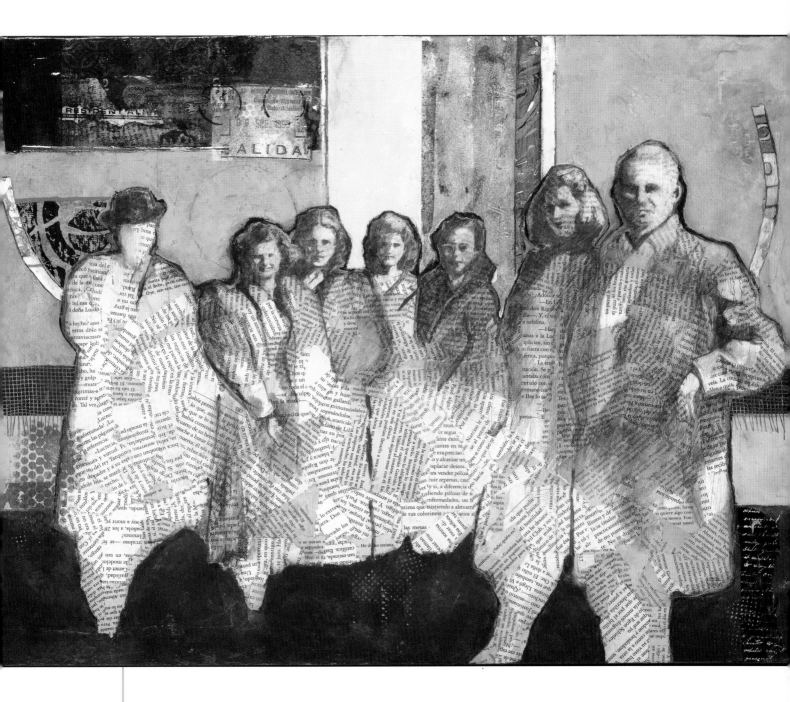

Departure (Salida)

Rosa Ines Vera | 18" × 24" (46cm × 61cm) | graphite, acrylic, book pages, marbled papers, found objects on wood panel

This piece is a very personal one and took more than a year to complete. For some time, I have tried to express through my work the upheaval of immigrating to the United States as my family did. I started this work with pages ripped from books written in Spanish and finally chose a photo of my family from the late 1940s as they boarded a boat that would bring them here. As I outlined the figures, their faces gradually became important, and I drew them in graphite with some acrylic paint. I used the exit ("salida") stamp from my passport and part of my green card visa.

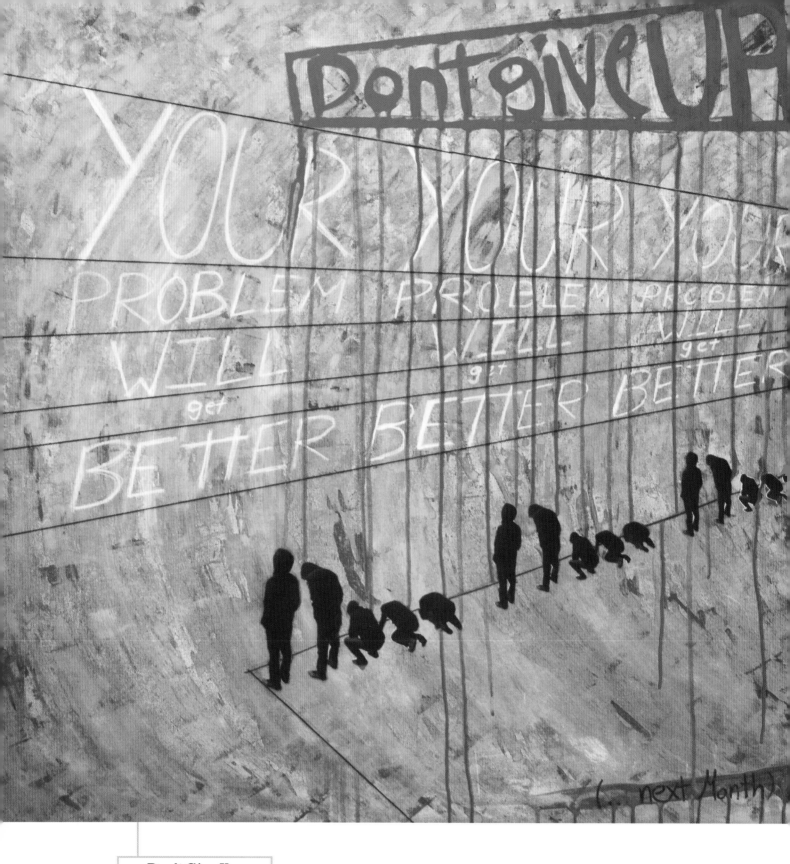

Don't Give Up

Jose Gallo | 30" × 30" (76cm × 76cm) | acrylics, thread, photography, charcoal, permanent marker

Don't Give Up is a progression of achievements and frustrations. As we work toward our dreams, we will always find ourselves stuck at some point. Unfortunately, this becomes a vicious cycle we decide to become part of. It is our way of learning how to persevere and achieve. But is this the only way? Why do we have to suffer to learn? Why later and not now? The answer is simple: We choose to do so.

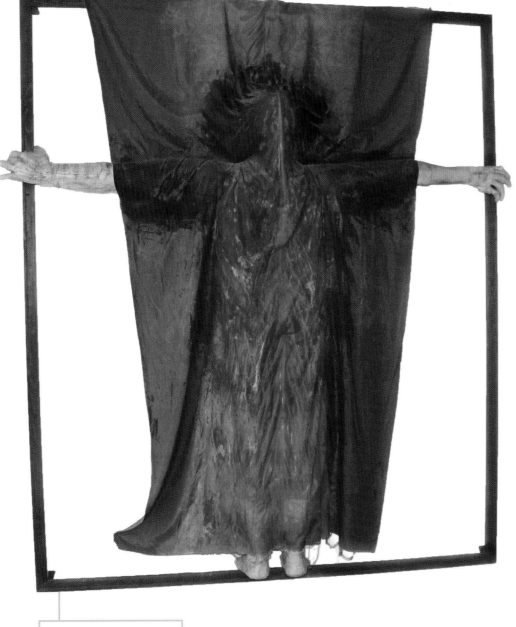

Self-Portrait

Becky L. Bane | 60" × 72" (152cm × 183cm) | fabric, wooden canvas supports, wire, plaster gauze, fabric stiffener

Before making **Self-Portrait,** I went through a dry spell in terms of making art. To get myself out of this mood, I played with reverse dying (a.k.a. discharge dying) a long piece of silky black fabric. Binding the fabric in a tie-dye method, I repeatedly dipped sections in a diluted bleach solution. The result shocked me as I cut the bands and rinsed the fabric. Instantly inspired, I saw a body in the bleached-out orange flame shapes that appeared in the fabric. I made casts of my arms and feet and built a rough form to mimic my body. I used fabric stiffener and draped the fabric over the form, then assembled the pieces.

That piece of fabric was a dream come true. Some would say it was a happy accident, but I knew better. It reminded me that as an artist, you have to do the work every day in order to find the inspiration. As to other people's reactions to **Self-Portrait,** they tend to fall into three categories: 1. Those who try to ignore it, but can't; yet they won't talk about it. 2. Those who are happily excited about it and can't stop asking me about what it means. 3. Those who are deeply disturbed—even angered—by it and demand to know what it means! I try to respond to each with the most calming smile I can muster.

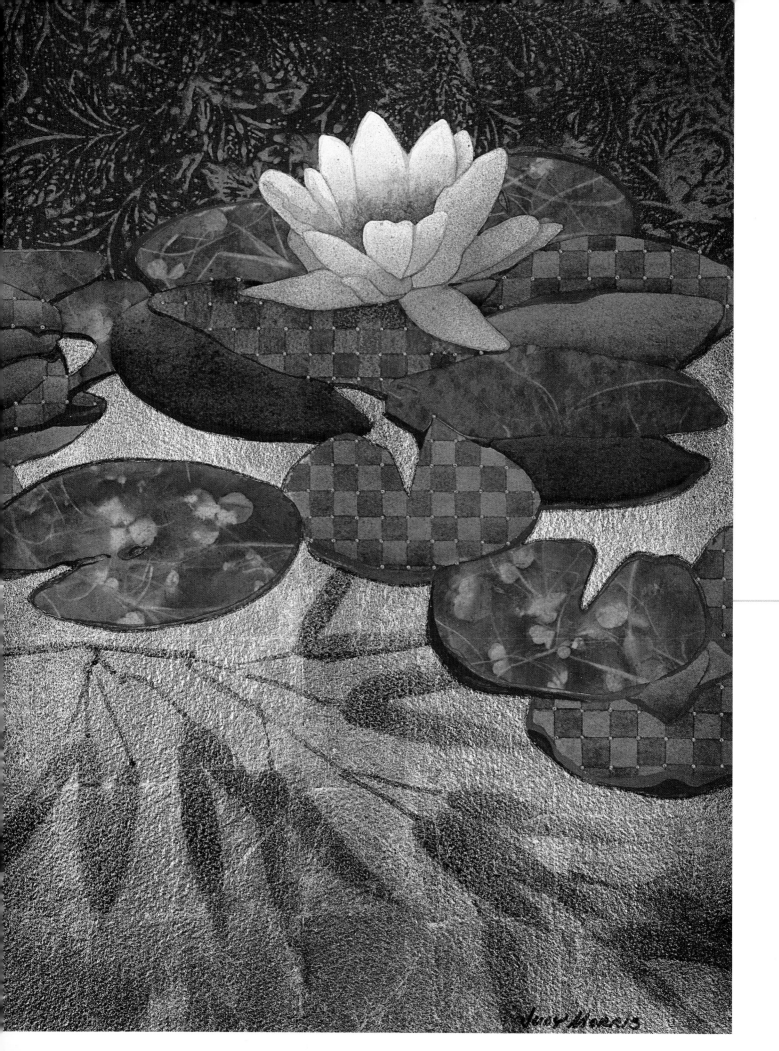

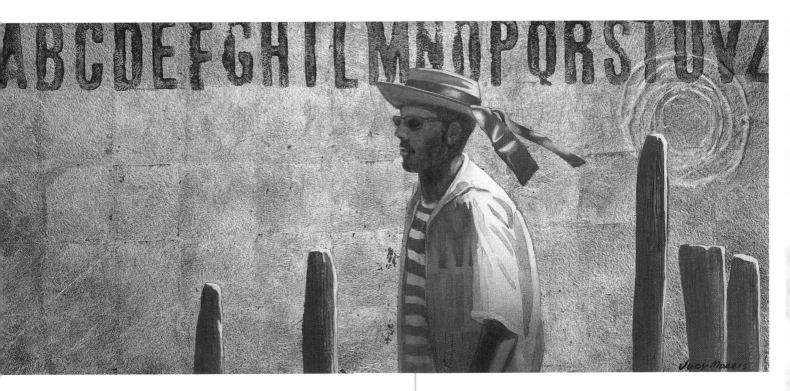

My Garden Pond

Judy Morris | 21" × 15" (53cm × 38cm) | transparent watercolor, collage, silver leaf, beads on 300-lb. (640gsm) cold-pressed watercolor paper

My Garden Pond started life as a disaster. I had read about a new stamping technique (using bleach) that would add a unique texture to the painting surface. I tried that technique at the top of *My Garden Pond*. The result was a success! But in using the technique, I created a mess on the rest of the paper. The painting stayed on the oops shelf in my studio for years. One day I looked at the piece and thought to myself, "I'm going to have fun. Anything goes!" I "fixed" the spoiled parts with collage and silver leaf. I added a bit of traditional watercolor. I sprayed through a stencil to create the bamboo shapes, and in the end, sewing on little, silver beads seemed like the perfect finale!

Italiano Classico

Judy Morris | 12" × 26" (30cm × 66cm) | transparent watercolor, gold leaf, latex paint on 300-lb. (640gsm) cold-pressed watercolor paper

When I painted *Italiano Classico*, I gave myself a challenge. I wanted to capture my memory of Venice without including every complicated detail that is sometimes found in paintings of Venice. The single gondolier and his traditional hat speaks of the hundreds of men who propel the black gondolas through the mysterious canals of Venice. A few pillars represent water, as well as the thousands of other pillars that line the canal edges. The classic Italian alphabet, with five fewer letters than the alphabet we memorized as children, stamped at the top, reminds me of the depth of history found within the city limits. The gold leaf symbolizes the wealth and opulence of years past. My challenge proved to be a success!

On Wings of Light

Sharon J. Navage | 34" × 27" (86cm × 69cm) | monoprint with stitched, layered relief print, collage elements, hand marks on Revere

I attended a workshop by Lennox Dunbar where I learned to carve MDF board and treat it as an intaglio style plate. These gave me my background image with an open area in the middle. I made a relief carving of a bird from one of my photos and decided to print on fabric instead of paper and bead it. I then hunted through my stash of collected items for compatible colors to stitch into several layers, including the ribbon. The remaining pieces were added over a number of days. The story is in the hand marks, "I found a bird on the road to Paris." . . . All roads lead to Paris in my dreams!

Signs of Hope
Artistic Firsts, Optimistic Outlooks, Helping Others

As artists trying to find our place in a creative community, we tend to seek validation of our abilities through a variety of milestones along our paths of growth. Without some level of external acknowledgment we often wonder how good our work really is. As Fran Dussaman reflects, "Like many artists starting out, I enjoyed the process of creating but didn't know if my work had any artistic merit."

Having one's work accepted to a juried show, being invited to display work in a gallery and making a first sale are all examples of achieving a dream, and these events always suggest we must be doing something right! With this sort of validation, we are given the great gift of hope.

Hope is also something many artists try to encourage through a message attached to their art. Sometimes it's reflected in the vision for a piece, such as Carole Belliveau's belief in "the potential in every child and the promise of our ever-renewing chances in life through creativity," and sometimes it's through the act of helping another, such as Tejae Floyde did with her art when she volunteered to raise money for a friend.

Sometimes a little hope is all we need to get us through the day (or the painting).

" My feet lead me to where my heart has always been."
• Diane Cook

" Instead of focusing on the finished product, just start creating. The piece will tell you what it wants to be, and sometimes it will be completely different than your original vision." · Fran Dussaman

Desperado

Fran Dussaman | 10" × 8" (25cm × 20cm) | joint compound, acrylic paint, stamping, wire, plaster wrap, rebar tie wire on plywood

Like many artists starting out, I enjoyed the process of creating, but didn't know if my work had any artistic merit. I finally found the nerve to enter three pieces in a local juried art show. It was a scary proposition. Could I handle the possible rejection? Would I still enjoy the process of creating if they decided my work didn't have any artistic merit? Turns out my fears were unfounded. Two of my pieces were selected, and *Desperado* took first place in its category! Not only was my work not rejected, I'm now officially an award-winning artist!

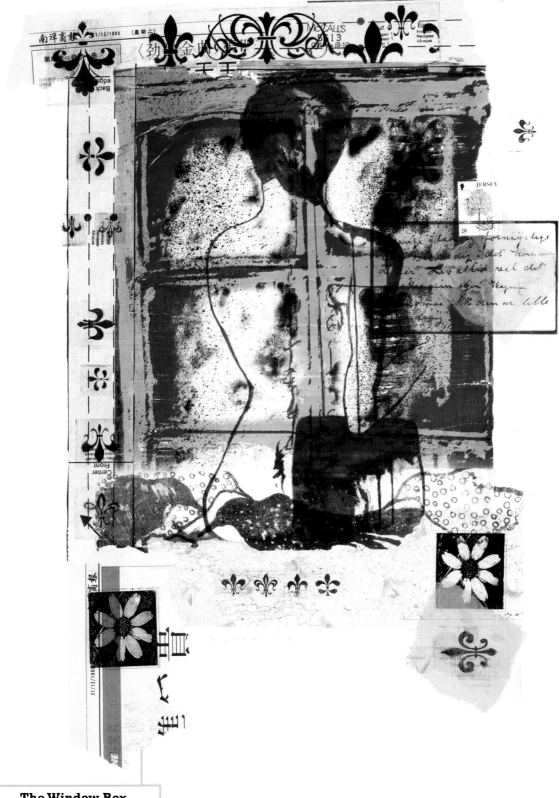

The Window Box

Sharon J. Navage | 28" × 22" (71cm × 56cm) | solar plates, polyester litho plate, chine collé collage elements, image transfer, digital printed acrylic skin on Rives BFK

A dream of every artist is validation. This can mean any number of different things to other artists. Validation for me was the invitation to this particular show.

This piece was created specifically in response to an invitational printmaking mentor/prodigy exhibition. My idea was to stay true to my love of mixed media while meeting the printmaking criteria of this show.

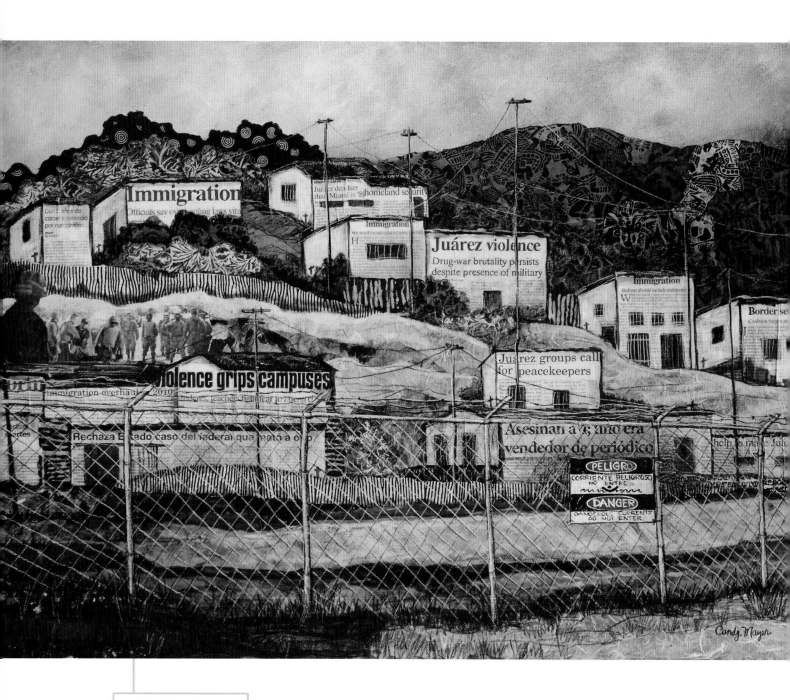

La Frontera

Candy Mayer | 30" × 40" (76cm × 102cm) | collage on canvas

When I moved to El Paso thirteen years ago, my dream of becoming a full-time fine artist was realized. Coming from Iowa, I was fascinated by Mexico and the borderland. My husband and I traveled extensively, absorbing the culture and landscape, which greatly influenced my art.

But as Mexico became increasingly dangerous due to the drug violence, we had to curtail our travel. The separation of the two countries was never more evident than in El Paso, as El Paso and Juárez were virtually one city before.

In this collage, I wanted to express my sadness over the violence. It was the first time I had actually made a political statement with my art.

As I write this at the beginning of 2013, Mexico is becoming safer and more settled.

I dream of the day that my husband and I can once again explore that beautiful and exciting country.

Porch Door

Aleta Jacobson | 10" × 7" (25cm × 18cm) | altered photo, watercolor-stained paper, watercolor, acrylic, gesso on 140-lb. (300gsm) cold-pressed watercolor paper

The door in this painting represents a rusting over of that space that holds your dreams. If you try (scratch), you can bring it back to life. I created *Porch Door* by pushing paint to change the photo into something bright and hopeful, then gessoed over some places to control the brightness—just as you would refurbish and reclaim a dream.

Golden Child

Carole Belliveau | 40" × 30" (102cm × 76cm) | acrylic over 24-karat gold leaf on stretched Belgian linen

While visiting a museum, I suddenly saw in my mind a fully formed painting of a "golden child" on the wall. To achieve this vision, I worked my favorite model into a scene at the ocean, using Photoshop for the sketch. The painting is on Belgian linen with clear gesso. Acrylic paint and knife scrapes through the 24-karat gold leaf achieve the texture.

My image is representative of the potential in every child and the promise of our ever-renewing chances in life through creativity—an image of beauty and hope. This painting is the sum expression of all my paintings—my dream realized.

Flow

Gia Whitlock | 20" × 20" (51cm × 51cm) | collage, acrylic paint, pencil on birch panel

Last year I was juried into a large arts festival. I had three months to reach my goal of sixty to seventy pieces for the show. For years I had dreamed of being in a festival like this. More important, I had a bigger dream: to be happy with my work.

I collaged and painted day and night to reach my goal for the festival. With two small children at home, I did not have the luxury of second-guessing myself at every step of the process. So I subdued my bossy inner critic and let intuition guide me. I've never been happier with a body of work.

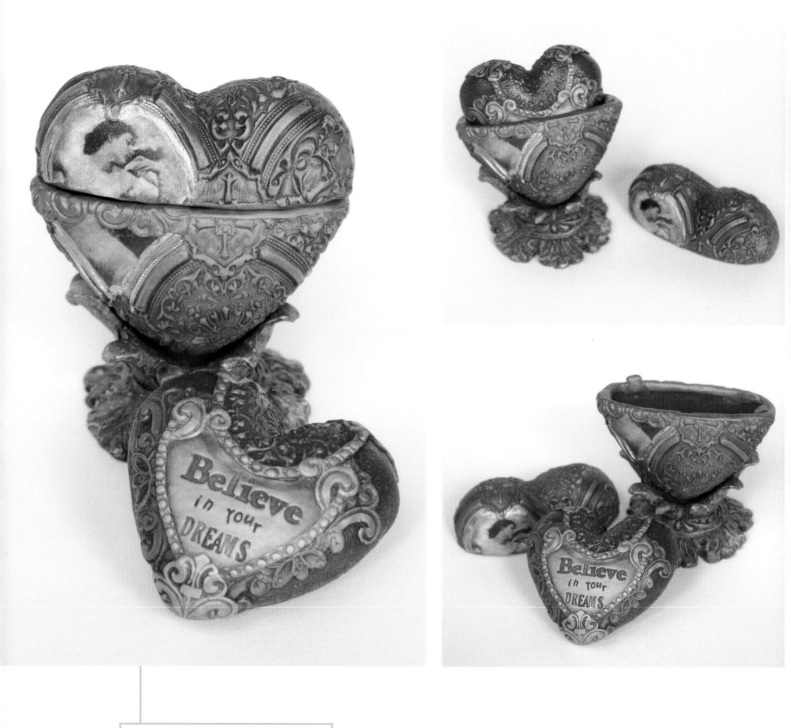

Dreams Encased Heart

Tejae Floyde | 7" × 2½" (18cm × 6cm) | polymer clay stamped with transferred image, ink and acrylic paint | photography by Anke Humpert

I met Kristen Powers on Facebook. She had worked for a rubber stamp company years before, which was a great experience until she decided to part ways with the company and the owners wouldn't allow her to take her beloved art with her. The hurt she experienced from this became determination to start anew and open her own rubber stamp company. She was asking for donations to make a cross-country trip to pick up rubber stamp equipment and bring it back home to set up shop. We were strangers, but I believed in her dream. So I volunteered to create the *Dreams Encased Heart* to get the word out and encourage people to donate to her cause. Each participant who donated had a chance at winning the heart. After several weeks, we had raised some money, and although we were still a little short of our goal, it didn't matter because the success we had sparked a fire in Kae Pea to follow through with her dream. And today her dream has become a reality. Her rubber stamp company is called rubbermoon.com.

"My feet lead me to where my heart has always been." • Diane Cook

Hope Flies

Diane Cook | 1¹⁄₂" (4cm) | oxidized brass wing cold-joined onto accented and etched brass cuff

Hope Flies was serendipitously born after purchasing an angel wing component. I loved the crisp details this wing possessed, so within a short time, I began manipulating it to see if it could be attached to one of my etched metal cuffs.

Hope Flies symbolizes a deep satisfaction I have felt that began with the very first piece of jewelry I designed, which was a simple string of beads on an elastic cord. I find myself constantly striving to refine my skills, and I count myself blessed with the opportunity to now be teaching and sharing my passion for jewelry designs at national art retreats. I suspect when I look back at this part of my life, I will see that it was the beginning of a lifetime of dreams, finally realized. (I worked for more than twenty years in the financial world and did not begin fulfilling my artistic life until the end of 2010.)

So why the name *Hope Flies*? The word "hope," stamped onto a hammered piece of metal, symbolizes my faith. Gently tucked behind the wing, this small word reminds me of what I believe and what I choose to cling to, in both good times and bad. The wing symbolizes flight, and what could possibly carry me to places I want to go faster than an angel's wing?

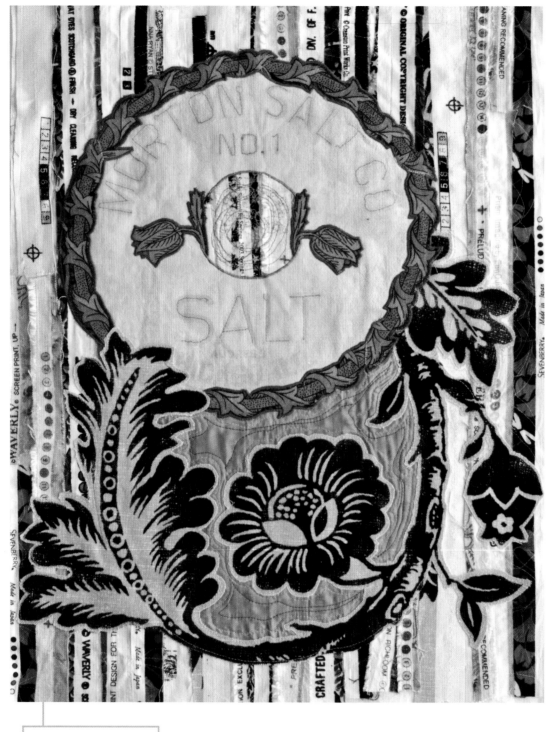

Morton Salt

Abby Feinknopf | 23" × 22" (58cm × 56cm) | fabric selvage base, vintage flour, salt and sugar sacks

Setting goals remains critical to me as a self-taught artist. One of my early goals was to exhibit my work in a particular gallery. That opportunity came by chance, and *Morton Salt* was one of the pieces in that first show!

It still sends me a strong message. The central, circular motif has a nautical feel, reminding me of a ship's wheel. I always envision a white-uniformed captain looking out to sea. That is how I continue to approach my life and art, always looking ahead for the next opportunity and to meet the next goal!

Beguiling

Aaron Bell | 9" × 12" (23cm × 30cm) | watercolor on rag paper

When an artist creates something, it is a very personal extension of his or her core existence. I think every artist experiences a kind of surreal sensation when they are recognized or sell their first creation. It's the point where everything preceding it comes together, whether it's been a hobby, a life's dream or years of school and hard work toward a professional art career. It's when you are able to step back and say, "Wow, someone likes something I've created enough to purchase it."

For me, it was one of the most humbling moments of my life. In my case, painting was a hobby. Until that point of recognition, you have friends and family telling you that your work is good, but you still wonder if they are just being nice. The owner of the gallery where my first painting sold realized I was having trouble getting my head around the whole thing. She said that when someone buys a work of art, they are not just buying "wall filler."

After I thought about it, I realized that I had created (with my style of painting) something that someone would hang in their home or cabin to enjoy, and it would most likely be handed down to another family member, just as I have a clock that my grandparents owned. I realized as artists we are leaving something behind that might survive generations of people who will enjoy our work and tie it to their personal family history. Can you imagine a better dream realized?

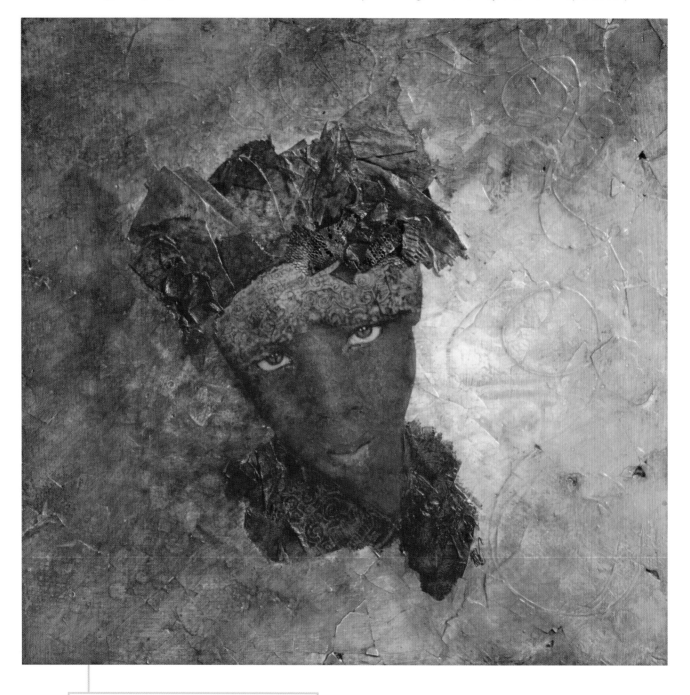

So, Where Do I Go from Here?

Eve Ozer | 12" × 12" (30cm × 30cm) | plaster of Paris, acrylic, colored pencils, stamping, coffee filters, sewing pattern paper, lace, glazes on burlap and Masonite board

This quote epitomizes my attitude to push beyond the ordinary. Let go and trust. The inspiration for this piece is from a photograph of a young Senegalese girl I'm sponsoring through school. By receiving an education, she has an excellent chance to realize her dreams.

Using burlap and plaster of Paris, I created a cracked surface, which I glued onto a square board. I applied acrylic washes randomly with a sponge, leaving the middle light so the image transfer would show. Using colored pencils and acrylics, I enhanced her image and made an acrylic skin, which I glued onto the surface. I painted on a headband and stamped into the wet paint to get the pattern.

I "sculpted" her turban and collar with coffee filters, pattern paper and lace. I ended with Van Dyke Brown, Burnt Sienna and transparent Red Oxide glazes.

Looking for Adventure

Sue Brassel | 24" × 36" (61cm × 91cm) | acrylic, modeling paste, sewing patterns, markers on canvas and watercolor paper

Busy with life and kids, I didn't embrace my artistic ability until I was fifty. I discovered that my creative work soothes me, causes me to view people and life differently and has helped my soul grow. Every day is an adventure.

It starts with blank canvas and scraps of paper and metals I have collected in my adventures . . . and the mojo begins to flow. As the scraps of paper and metals are placed and the paint flies, excitement builds. I am just an observer.

My dream was realized at my first show in 2012. *Looking for Adventure* was displayed and sold.

Artistic Awakening
Voice, Validation, Growth

For some, a creative awakening comes later in life than for others, and it's not until children have grown and left the house, or retirement from work frees up more time, that embracing art making (and the title "artist") becomes possible. For all of us, seeing our work evolve over time (and our inner selves with it) reveals much about who we are. As Julia Hacker puts it, "Enlightenment. Discovery. There are no more compelling reasons to be on a road. And there are no more compelling reasons to paint."

Crystal Neubauer expresses this a different way, when referring to the events that revealed she should take an artistic path: "It wasn't just about becoming an artist; it was about becoming me."

An awakening also comes about when we discover our authentic artistic voice. It can take some of us what feels like forever to do this. As Laura Lein-Svencner notes, "Making the decision to create a large body of work wasn't as difficult as finding my own artistic voice was." But when this voice is discovered, it seems the pain was worth the wait, as Julie Birman shares: "I had 'arrived' and my dreams were realized, and I am happier than I have ever been."

" *Maybe not 'anything' is possible, but when something feels absolutely in tune with your deepest self, when you start acknowledging it and taking steps toward it, when you are alert to the signs that are sent your way, then it has every chance of turning into something beautiful!* **"** • Laly "Lalyblue" Mille

Arrival

Julie Birman | 30" × 24" (76cm × 61cm) | acrylic, mirrors, jewels, three-dimensional paint mixture on canvas

I grew up in a household that did not value art, and my parents' perspective was that I could not make a living as an artist. I did not attend art school, nor did I paint on canvas again for thirty years. I started studying authentic yoga and through my awakening found the place that touched my soul and brought forth this painting.

Arrival represents transformation and the celebration of being able to see inner beauty within myself and freedom from false beliefs.

I had "arrived" and my dreams were realized, and I am happier than I have ever been.

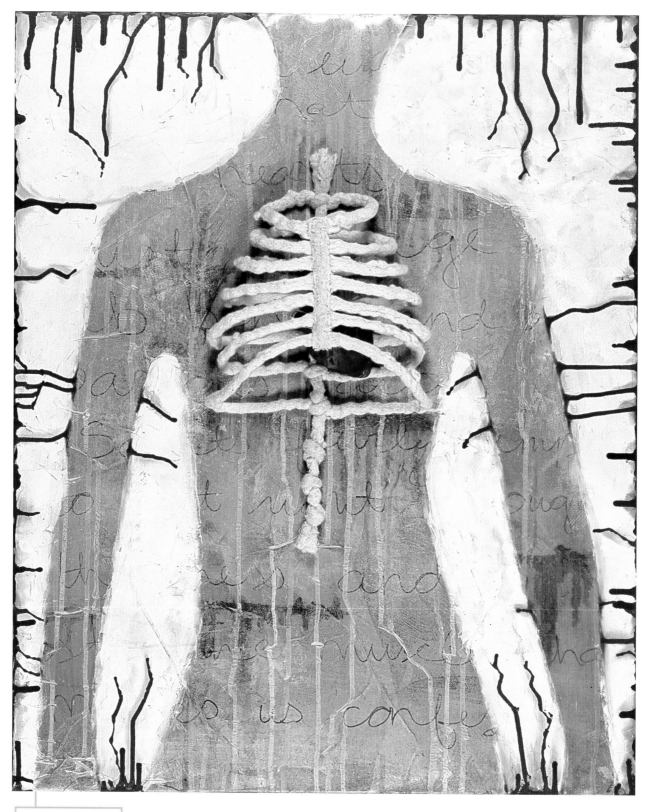

Exposed

Marnie J. Blum | 30" × 24" (76cm × 61cm) | acrylic, ink, modeling paste, PanPastel, cotton cord, wire, polymer clay on canvas

For years I struggled to define what being an artist meant and whether I qualified for that title. After denying myself that luxury for most of my life, I finally realized that being an artist is not about me having a degree or having filled sketchbooks. It's about me needing to create, needing to tell my story through art, and not needing to do anything else to be happy.

While I have been creating art in one form or another all my life, *Exposed* is my first unadulterated work since I had this realization. It represents my own dream realized: I am an artist. As to the meaning of the piece, it is layered and complex, and I leave it up to the viewer to experience it in his or her own way.

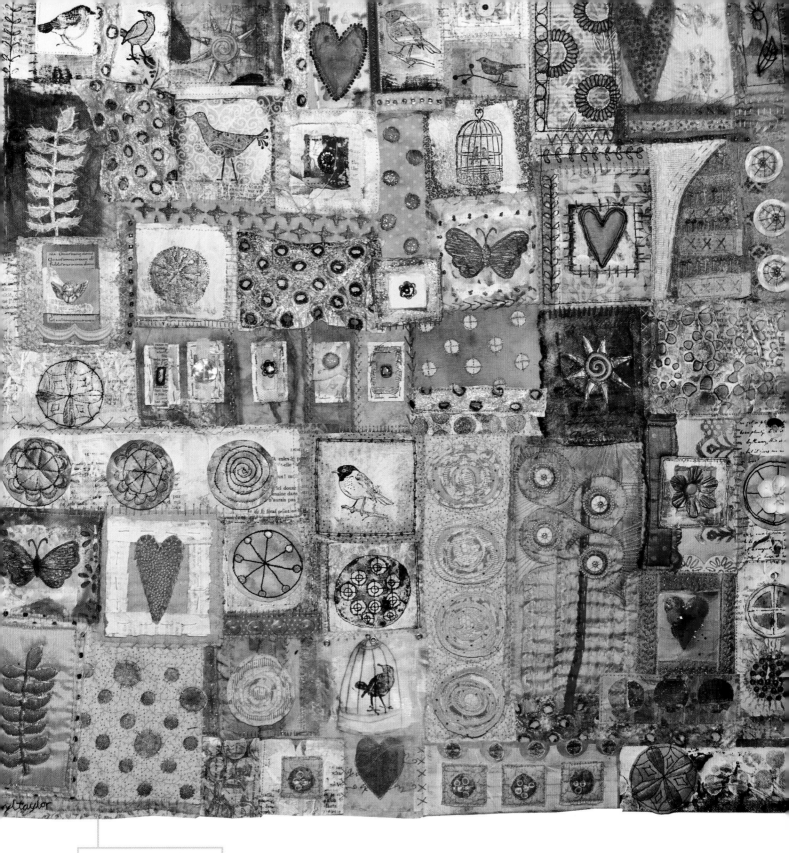

Synchronicity

Beryl Taylor | 23" × 24" (58cm × 61cm) | hand- and machine-stitching, paint, fabric, paper

This artwork is not specific to one moment or life event; it is an amalgamation of several different motifs. This is one way to view life itself, as a series of individual moments and events.

This work is made from numerous different images that can reflect the dream world—many different images and clips that become joined together and create a whole dream. When the motifs and shapes are positioned together, they create balance in form and composition; they become a whole.

"Three small things a day related to art can add up to a huge amount of artwork accomplished over time!" • Terry Honstead

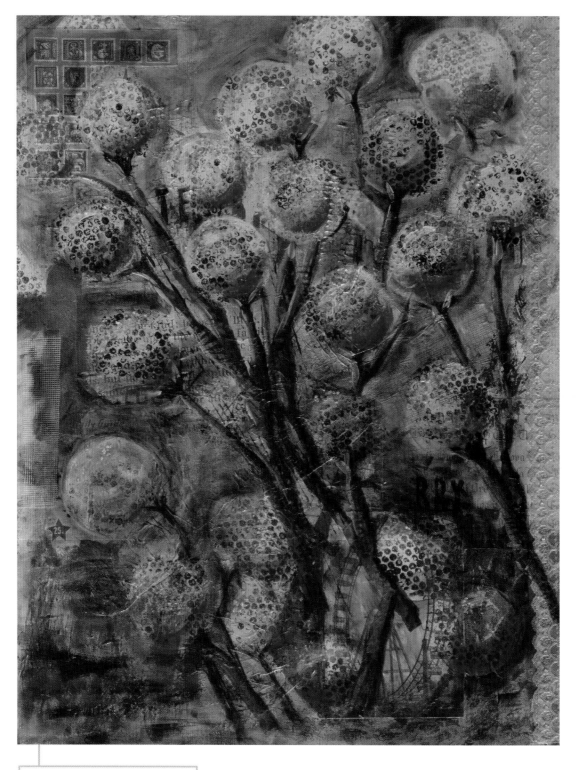

Summer Blossoms

Terry Honstead | 40" × 30" (102cm × 76cm) | acrylic, old pictures, paper, lace, gold mica flakes on canvas

The first layer of this painting consists of many things that are very personal to my life. I included one of my baby pictures along with an old report card from the third grade. I also have some writings relevant to me and a Ferris wheel, which represents my ancestors. (My grandparents were with the carnival, and I remember getting free rides as a young child!) I also used some old lace that was my great-grandmother's. On top of the personal pieces, I stenciled and painted the blossoms, which represent my life unfolding and blossoming into what I am today.

Singing My Song

Laura Lein-Svencner | 36" × 36" (91cm × 91cm) | collage on canvas

Making the decision to create a large body of work wasn't as difficult as finding my own artistic voice was. Turning inward and really listening to what was being said, I set aside foolish nonsense I heard in my head and trusted my intuitive heart. *Singing My Song* is about letting go of all that is expected and tuning into what is real and true.

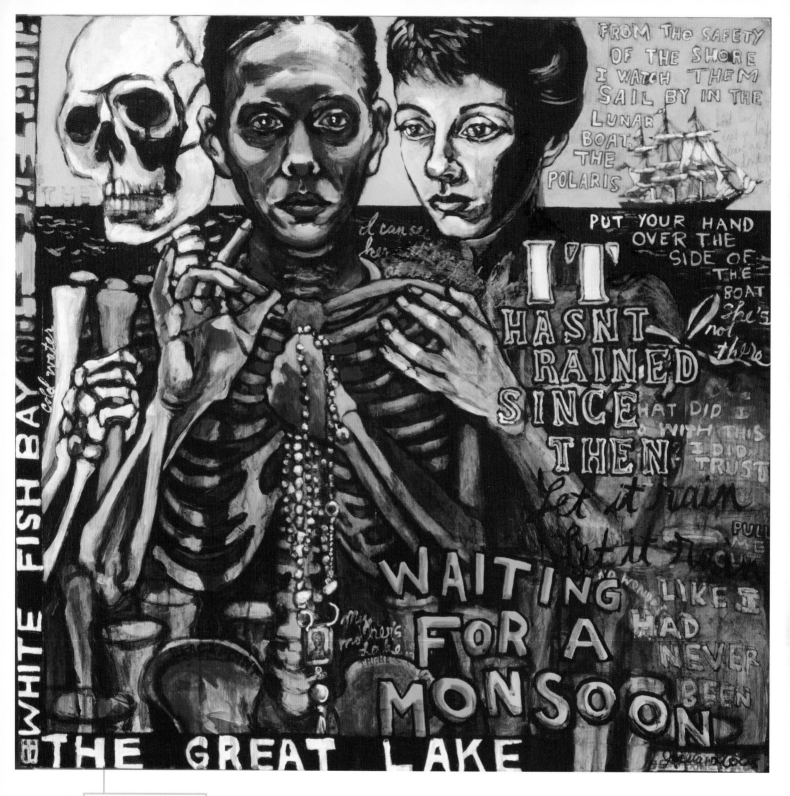

Let It Rain

Juliana L. Coles | 24" × 24" (61cm × 61cm) | mixed media on gessoed wood panel | photography by Pat Berrett

Teaching for the past ten years nearly strangled the life out of my artwork, and me. My dream was to make a commitment to my artist self by creating a substantial body of work and having an exhibit. For me, creating work of authenticity and meaning is important, so for this exhibit I chose (or rather, it chose me) to create mixed-media pieces that expressed my grief at losing my parents, aunt, stepmother, three friends and my cat, Petey, in a very short time period.

This particular piece about my mother's passage is true to my dream. I did what I set out to do: discovered some inner healing and awakened and moved others as a result. I felt pretty kick-ass about the whole show. I met my demons, and I painted through the tears anyway.

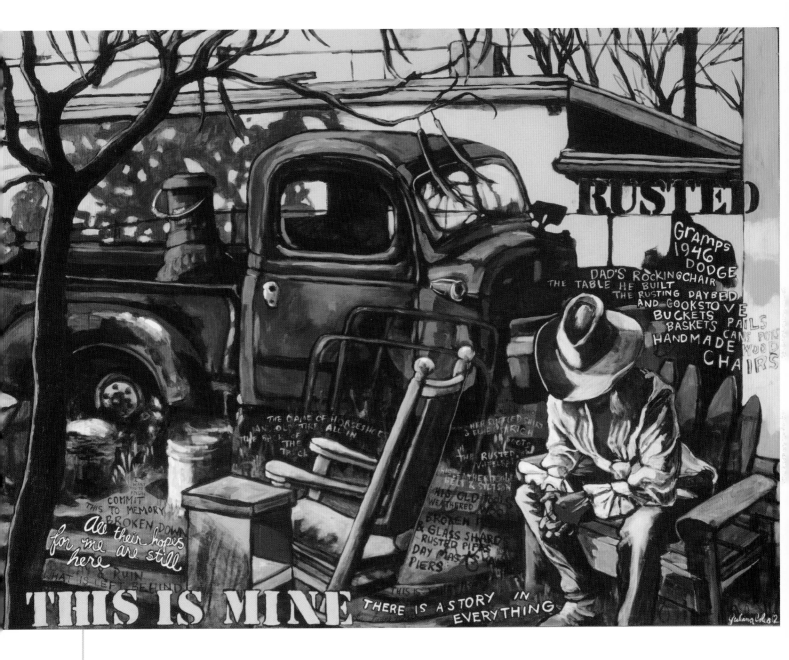

This Is Mine

Juliana L. Coles | 36" × 48" (91cm × 122cm) | mixed media on gessoed wood panel | photography by Pat Berrett

This painting began as a study of rusting and rotting junk in my backyard. An exhibit deadline was coming up, and an artist friend said, "Hey, finish that truck painting; it's almost done!" And I thought, "Yeah, I can do this." But the more I worked on it, the worse it got. When I called my wise friend to tell him I ruined it, he said, "Well, okay, now you have to forget what you set out to do and do what the painting wants you to do." I was frustrated, but I knew he was right. I had been struggling to do something I wanted others to like by leaving my words and my style out of it, but when I was true to who I am as an artist and how I work, the painting unfolded naturally.

*"**Give rise to your future through creative endeavor.**"* • Judith Randall

Actualization

Judith Randall | 24" × 18" (61cm × 46cm) | acrylic, molding paste, paper, bamboo sticks, wire on primed hardwood

It has taken most of my life to realize that my dreams actually do materialize, usually on a larger scale than first imagined, and my artwork plays a huge role.

As my process moves forward, it becomes a source of heartfelt meditation. From this comes a reminder that the dreams one holds in the heart can touch many when actualized.

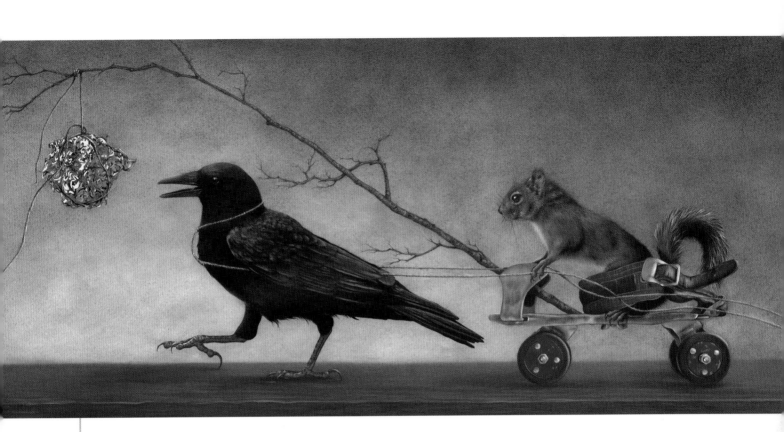

Foiled Again

Eileen F. Sorg | 12" × 28" (30cm × 71cm) | colored pencil, ink, transparent watercolor on Arches 140-lb. (300gsm) hot-pressed watercolor paper

To me, art is about growth. I am fortunate to be at the point in my art career where I am confident in my drawing abilities and my chosen mediums to be able to fully express my imagination. When I first began working in colored pencil, each piece I created was a stepping-stone to the next. I would gain more confidence each time, but my work was very literal. Fast forward to today, and I am able to see an image like *Foiled Again* in my mind and bring it to life on paper just as I envisioned it.

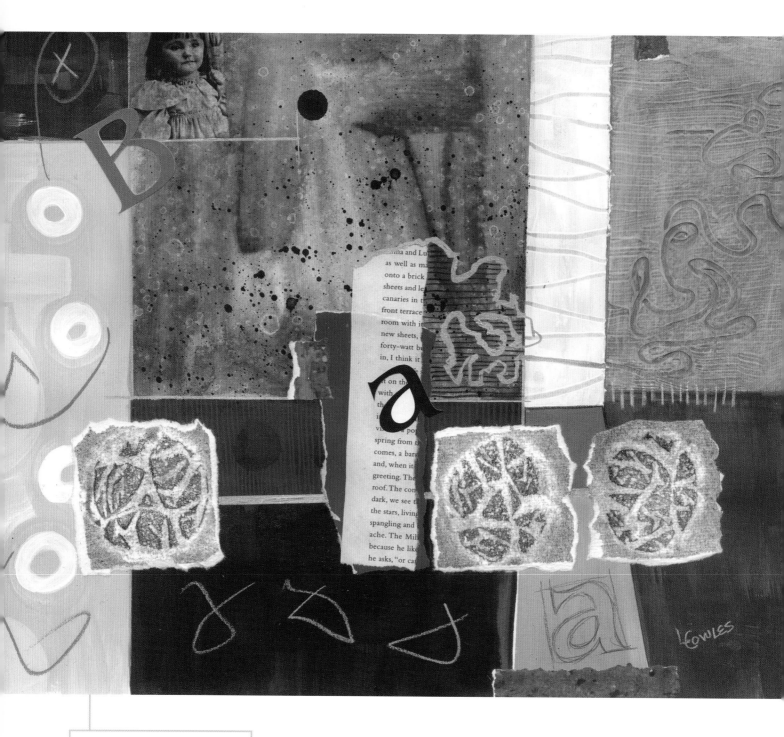

Getting from A to B

Linda Cotter Cowles | 11½" × 14½" (29cm × 37cm) | acrylics, inks, photo transfer and hand-printed/painted papers on 140-lb. (300gsm) hot-pressed watercolor paper

I've often admired paintings with a predominantly neutral palette. This image is part of an experimental series for which I had two objectives: work with neutrals and incorporate digital elements. I discovered that not only do neutral compositions need to be stronger in terms of tonal range, but also that variations in texture and line can play more important roles. I love to make unique digital elements by enlarging tiny things or taking a tiny portion of something large. I used that process to create the three medallions in the foreground.

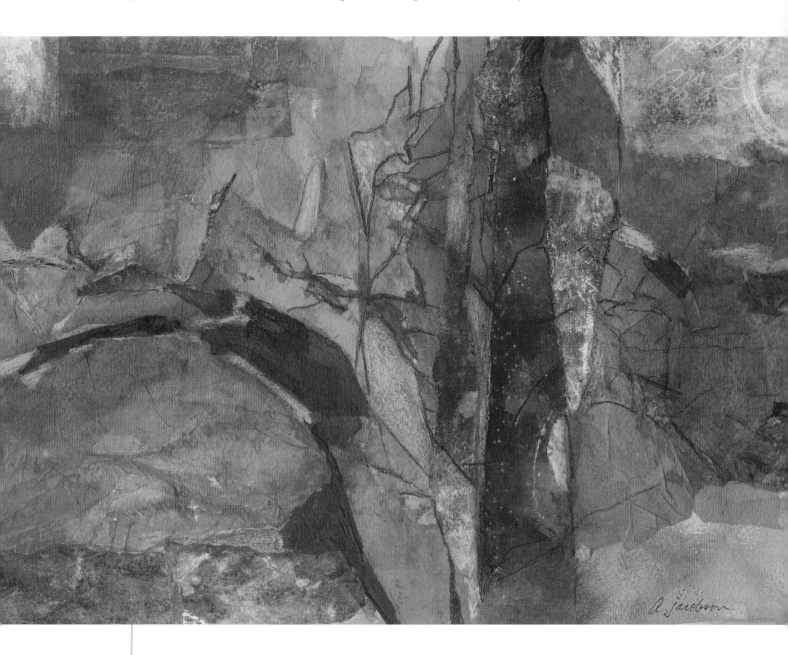

She's in There

Aleta Jacobson | 11" × 15" (28cm × 38cm) | watercolor, acrylic-stained papers, watercolor pencil, gesso on gessoed 140-lb. (300gsm) cold-pressed watercolor paper

I like the contrast of light and dark—shy and bold—with the figure emerging from the colors. Scraping into fine lines with watercolor pencils to create fissures became a contrast to the bright, smooth places. Overall, the piece reflects the experience of beginning to self-actualize.

I am inspired by colors, textures, papers, shapes and nature. One bit of colored paper can start a series of collages wrapped around that piece of paper.

Each work is my self-actualizing moment because I can create it to my specifications without dictation or influence from anyone else, living or dead, real or imagined. That is my dream, realized.

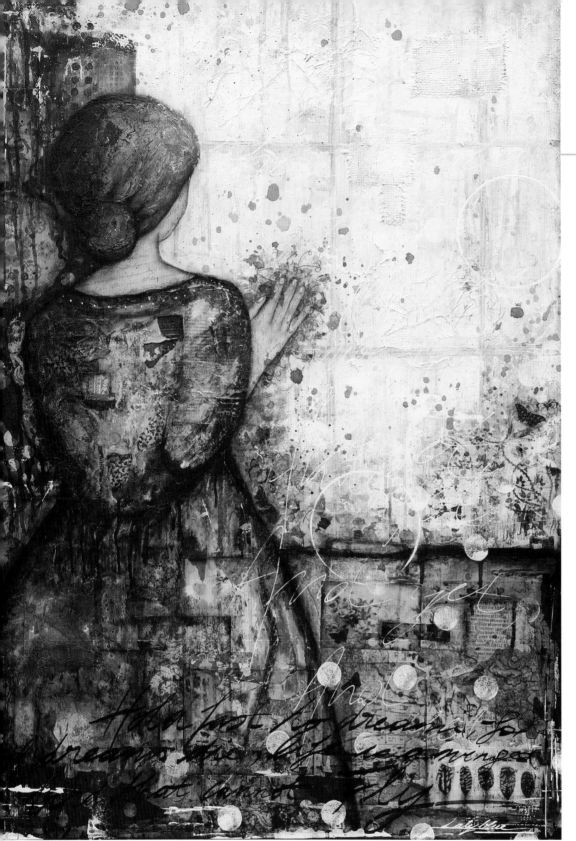

Touch the Dream

Laly "Lalyblue" Mille | 46" × 32" (117cm × 81cm) | mixed-media painting on canvas (collage, acrylic paint, inks, pastels)

Daring to call myself an artist is still pretty new to me. For years I was somehow "shut inside," only catching glimpses of this world of creative possibilities. But now it's time to reach for my dream and make it bloom under my fingers.

My love for words is very present in my art. I write intuitively on my paintings and add collage elements—clues that tell a hidden story, like a visual lexical field.

This painting is based on the Jane Austen character of Anne Elliot. As a young girl, she was persuaded not to follow her heart and to conform to society's expectations. Years later she finds the strength to fight for her dream and make it real!

" *Maybe not 'anything' is possible, but when something feels absolutely in tune with your deepest self, when you start acknowledging it and taking steps toward it, when you are alert to the signs that are sent your way, then it has every chance of turning into something beautiful!* **"** · Laly "Lalyblue" Mille

Deep Calls to Deep

Crystal Neubauer | 12" × 12" (30cm × 30cm) | collage, ink, acrylic on canvas

Many years ago, working as a project manager in the print industry, a co-worker handed me a mixed-media art magazine, saying she thought it might interest me. Opening those pages for the first time was like opening Pandora's box. Deep inside me, an ache of recognition stirred. There weren't words to put to it, but my life had changed in that instant.

Looking back, I clearly see the path that led me on this journey to becoming an artist. It hasn't always been clear to me when it was in front of me; much of the time I only knew enough to know what the next right step was and had just enough courage to take it. Often those steps did not appear to be taking me in the right direction, but always I would have a deep in-the-spirit confirmation of the step I was on.

It wasn't just about becoming an artist; it was about becoming me. About learning to let go of what I was "supposed" to be or do, and listening to the voice of truth reveal what I really was.

It was about listening to deep calling to deep.

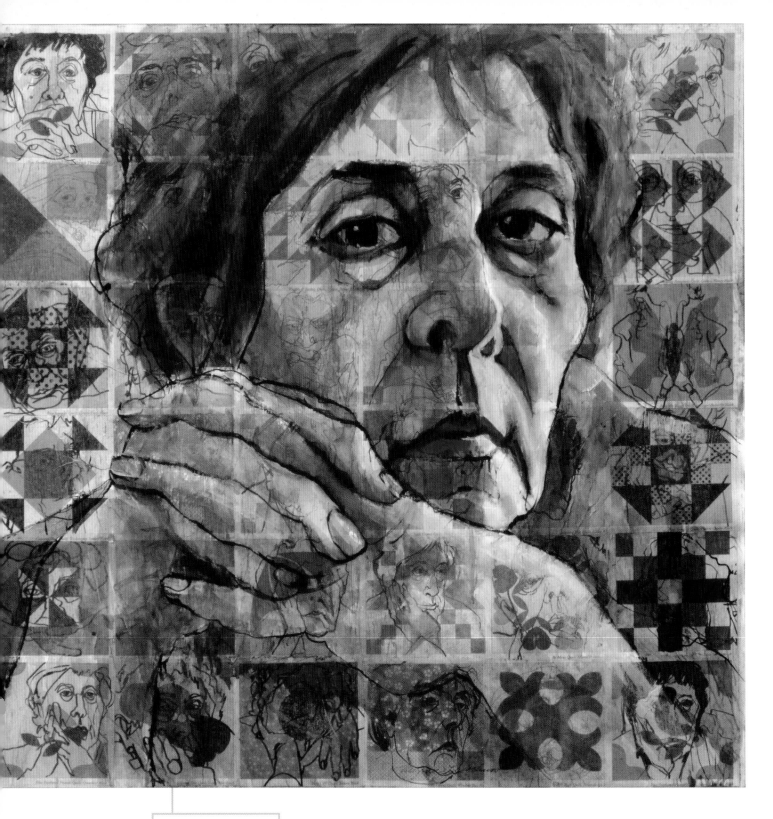

Fragments

Myrna Wacknov | 30" × 30" (76cm × 76cm) | watercolor, gesso, tissue, ink, calendar pages on watercolor paper

In order to realize my dream of being more creative, I create a new focus at the beginning of each year. I select three or four areas of interest to explore in depth. This expands my understanding and technical skill while creating limitations and fostering innovation.

Fragments was the result of my focus on self-portraiture as my subject, a drawing every day, working with a grid and incorporating collage and line into a painting.

I could never have envisioned this painting without the process of working through a series with imposed limitations.

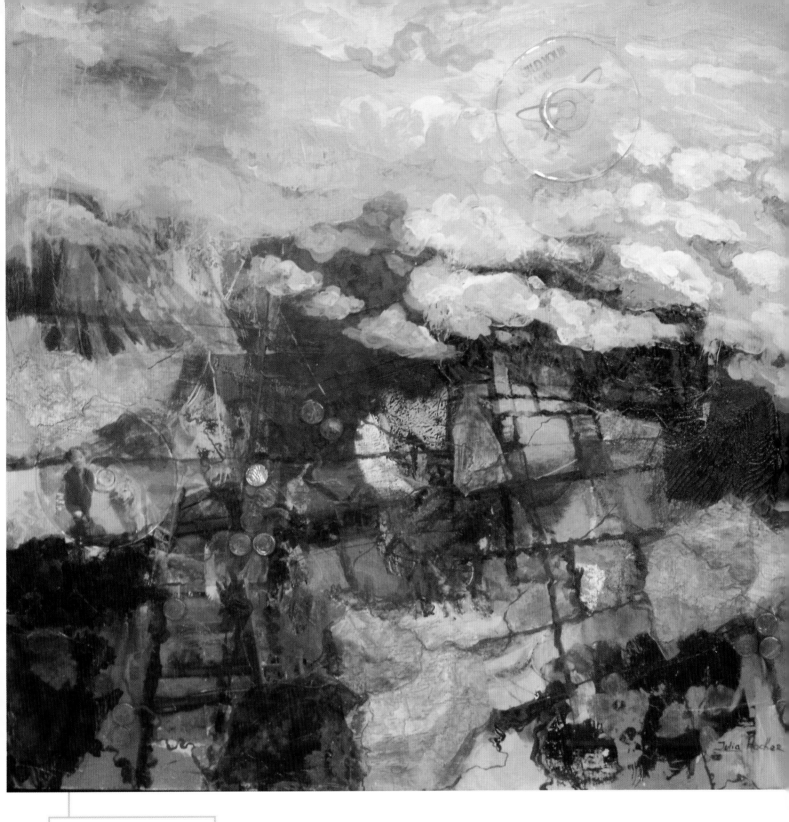

Under the Clouds

Julia Hacker | 30" × 30" (76cm × 76cm) | acrylic paint, old map, gel medium, CD, glass tiles on primed cardboard

Enlightenment. Discovery. There are no more compelling reasons to be on a road. And there are no more compelling reasons to paint.

This artwork is a result of multiple techniques and layers of acrylic paint. At first I outlined the composition by painting the canvas in sepia and then applied collage from an old map guide. Next I made a few transfers in order to create mountains. Then sky was painted, and a used CD was glued on the surface. I kept painting details, and at some point, added small glass tiles to the surface.

Between Heaven and Earth: In the Garden Where Hopes and Dreams Dwell—View I

Francesca Galliano | 44" × 60" × 6" (112cm × 152cm × 15cm) | wood construction with copper, brass, pewter, clay, beads, glass, acrylics, solvent dyes, metals, pigment powders, resins, lacquer, Peruvian coral stones, antiqued copper nails, wire

At twelve, I left childhood behind in rural Cuba when I was airlifted to Miami. I began formal studies after my oldest child's colorblindness engendered an obsession with how the interaction of neurology, biology and psychology affected our perceptions of reality, of beauty and of the sublime. While completing an interdisciplinary Ph.D., I discovered the principles relevant to emotional- and spiritual-content communication underlying my work.

Advancing multiple sclerosis forced me to abandon my academic career. I dedicated myself, instead, to merging my passions and expressing deep insights dearly gained throughout my life.

As I draw on emotional, intellectual and physical experiences, I use carving, painting, metalworking and other methods learned as a child from my father and grandmother to construct mixed-media assemblages within a spiritual context.

Mystic Portrait: Spirit View XIV—The Triune Self

Francesca Galliano | 34" × 18" × 6" (86cm × 46cm × 15cm) | wood construction with pewter, copper, Peruvian black stones, basswood, oak, pine, clay, carnelian, pearl, obsidian, glass drops, acrylics, solvent dyes, metals, pigment powders, resins, lacquer, antiqued copper nails, wire

Aiming to nourish the soul and expand the intellect, I explore spiritual beliefs, where nature is central, by constructing assemblages. The unexpected juxtaposition of disparate materials, worked with modern tools using old methods, produces a tension that infuses the work with vitality.

Each assemblage's sculpted environment increases the focal image's impact by providing a context and completing its statement. I use organic forms, visual movement and perceived temporal change and flux to represent a personal iconography and mythmaking.

Often I've been told the intricate weavings, carvings and toolings encapsulate time, and by making their perception depend more on the light's quality and the angle of vision than on themselves, their interplay with light heightens feelings of flux.

French Façade

Nancy Stanchfield | 23" × 15" (58cm × 38cm) | collected papers, charcoal, acrylic paint on 300-lb. (640gsm) cold-pressed watercolor paper

To be an artist has been my lifelong dream. Not until my mid-fifties, however, did I summon the courage to take my first painting class, and I was captivated. From the moment I began painting, it was all-encompassing to me. It was like an open doorway, beckoning me to enter, and I never looked back. Years ago collage had been a favorite hobby of mine, and so it seemed only natural to incorporate collage elements into my paintings. In *French Façade*, I used fragments of French maps, French poetry texts and silver leaf papers as well as charcoal pencil markings.

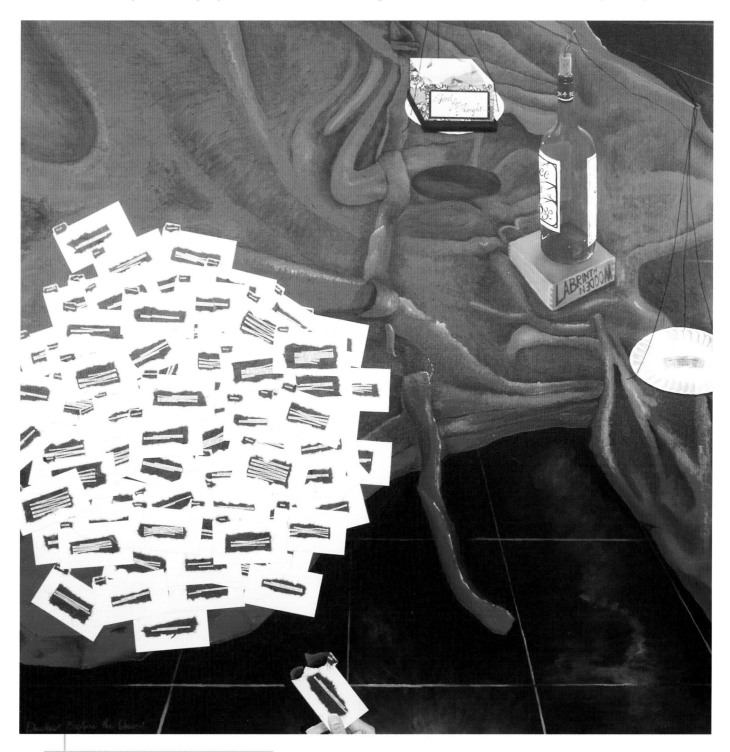

Darkest Before the Dawn

Molly Cassidy | 49" × 48" (124cm × 122cm) | dictionary definitions, cardstock, handmade papers, hemp, acrylic on birch | photography by JP

Consider labels, positive and negative. Painted in the Baroque style, this acrylic piece parallels the careless indulgence of categorizing with the decadence of the aforementioned period, provoking the viewer to confront their own inclinations. Instead of a red tablecloth, golden scales, etc., everyday household items are used, suggesting a late-night, self-imposed examination of one's own—unwittingly or otherwise—accumulated ''sureties,'' resulting in the conclusion that one epithet outweighs the rest: Through wordplay, a higher power's influence represents the artist's personal feelings, but, ultimately, the choice to burn is one's own.

Creative Process
In the Moment, In the Flow, From the Heart

The process of making art comes from a combination of physical skill and the skill of imagination. Many artists get as excited talking about the materials they use as they do about the part of them that thinks up what to create in the first place. For Lin Viglione, the process begins with self-awareness and emotion: "People always advise, 'Draw what you know.' I think it is more aptly stated, 'Draw who you are, what you feel.'"

Sometimes it's all about a passion we have with a particular color palette, a repetition of pattern or creating texture. These things delight our muse and keep us engaged. As Ronald Brischetto says, "I've always tried to push the envelope to create a compelling piece to make the observer want to deliberately touch the art."

However each of us likes to create, whichever medium we like to use, whatever life themes are the most inspiring for us at the moment, I think Jose Gallo sums up the reason we all love to engage in the creative process: "Just as when you have an idea, a dream or a goal, you set it, but it seems blurry. Sometimes you see it right in front of you, but you cannot catch it. That's the beauty of it: making something out of nothing and that experience speaking for itself."

"Persist in your practice, and believe that nothing—not time, materials or longing—is wasted in realizing your dreams ... work from your heart with things that you love."
• Marie Danti

Dayzees

Kristin Peterson | 40" × 30" (102cm × 76cm) | acrylic paint, ink, collage on canvas

Dayzees was created by reworking an earlier painting. The initial painting had words, which, at the time, had significant meaning to me, so I wanted to save them. When I finally painted over the words, I felt liberated. I then added napkins, paper, inks and collage to draw people in and make them want to touch and feel the layers and to really look at what is going on in the painting.

Count to Three

Linda Cotter Cowles | 17" × 14" (43cm × 36cm) | acrylics, tissue, hand-painted paper, pencil on 140-lb. (300gsm) hot-pressed watercolor paper

My artwork is built in layers. After the first few paint strokes were applied to this image, it reminded me of a scene in an imaginary workroom with a bench against a well-worn wall. I followed this theme as I added painted and collaged elements. There was no conscious effort to make it look like a particular place, just the idea of how a composition could be created by the seemingly random placement of shapes and textures representing the tools and materials of the occupant's work.

Kokoro of the Sea

Karen E. O'Brien | 36" × 36" (91cm × 91cm) | acrylic, collage, ink on canvas

The word "kokoro" literally means heart. It can be translated as "the heart of things" or "feeling." This painting is a dream realized because I paint from the heart. I work intuitively and let the art evolve from unplanned marks and accidents. I approach the canvas as a playground, and when my work is going well, I am lost to the process. I work on several canvases at the same time, looking for clues to tell me what to do next. I continue to alter the surface with marks, color, collage and texture until I find a connection, figure or shape that reveals the story to me. My goal as an artist is to communicate "kokoro," the heart of things from my dreams.

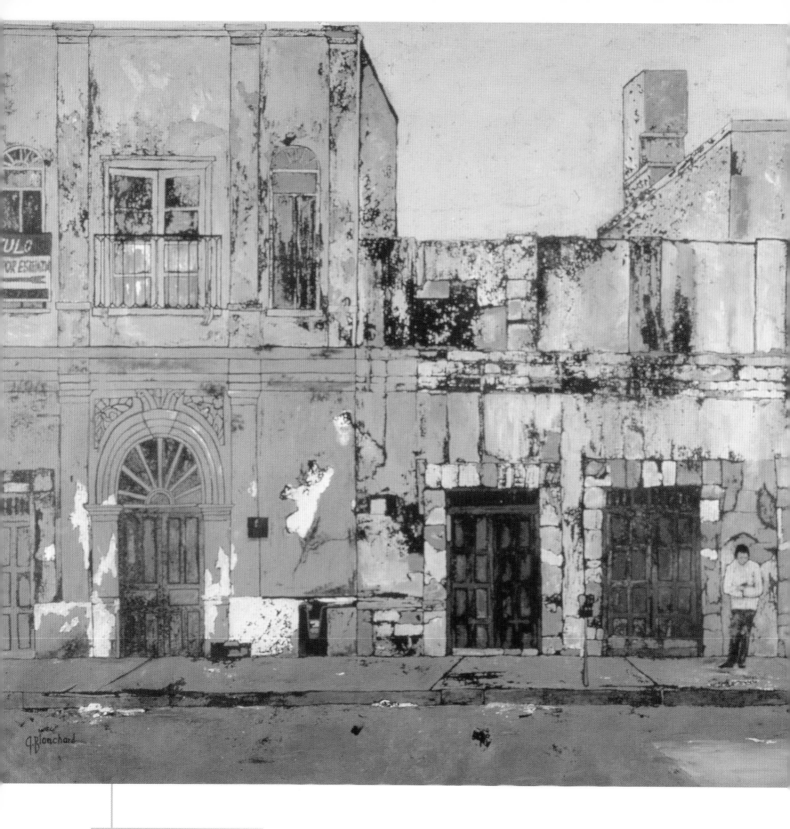

Mexican Façades

Georgia P. Doubler | 28" × 36" (71cm × 91cm) | tempera-ink resist, Arches 140-lb. (300gsm) cold-pressed watercolor paper

On a trip to Mexico City, I was intrigued by the cracked plaster of old buildings, fading colors and sagging walls. I couldn't wait to use the tempera-ink resist technique and interpret these in an exciting way. After drying the original paint layer, inking and washing the entire painting, I completed the painting with a choice of media—watercolor, acrylic or pastel—and improved the lines and textures when necessary with more India ink or a Sharpie pen. The technique is my choice for interpreting myriad textures, and each painting is an adventure!

Moth and the Flame

Georgia P. Doubler | 28" × 36" (71cm × 91cm) | tempera-ink resist, Arches 140-lb. (300gsm) cold-pressed watercolor paper

During the late evening at a studio in North Carolina, I went to my room, and over the door was this gorgeous Luna moth attracted to the light. I couldn't wait to tackle this scene with tempera and ink. The textures of the cracked plaster, screen door, bare lightbulb and soft green moth made a perfect subject for the technique. I had to decide how thick or thin to make the initial painted layer and where the ink would settle to create the various textures. I love the rugged look of tempera-ink resist and the colors and surfaces that are achieved.

Heaven & Earth

Lisa Agaran | 16" × 12" (41cm × 30cm) | mixed-media acrylic painting, collage with found objects on board

Each piece is created spontaneously and intuitively, allowing the painting to dictate the direction it wants to go. Forms, themes and textures organically unfold, guiding the next step in the process. I find this mindful path an opportunity to surrender to the present moment without parameters and predetermined definitions. It allows me to channel and transform the subconscious into art, by which I am able to discover new meanings and a deeper understanding of myself and of the world.

Possession

Loryn Spangler-Jones | 24" × 24" (61cm × 61cm) | acrylics, spray paint, Inktense pencils on canvas

My dreams create my art, and my art creates my reality. My very existence is dependent on my ability to deconstruct that which is. I do this on canvas, layer after layer, peeling away the static of life and exposing the many imperfections of the human condition, ultimately leading myself and the viewer into a place of raw vulnerability.

From within the experience of this place, I am able to make my dreams a reality, casting spells and creating magic with every painting.

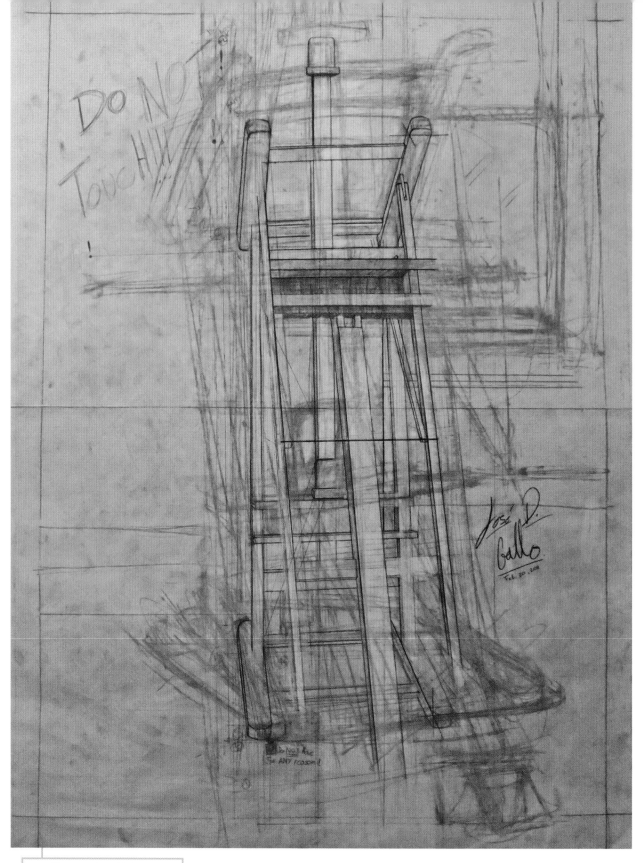

Emerging Lines

Jose Gallo | 48" × 36" (122cm × 91cm) | charcoal and color pencil on paper

I am still curious about what causes that much appeal from this piece. In fact, I have changed its title a couple of times already. *Emerging Lines* is a depiction of history. What history? The one I made with every mark over the fifty hours I spent working on it.

This artwork comments on the process of making art, rather than on the final product. Just as when you have an idea, a dream or a goal, you set it, but it seems blurry. Sometimes you see it right in front of you, but you cannot catch it. That's the beauty of it: making something out of nothing and that experience speaking for itself.

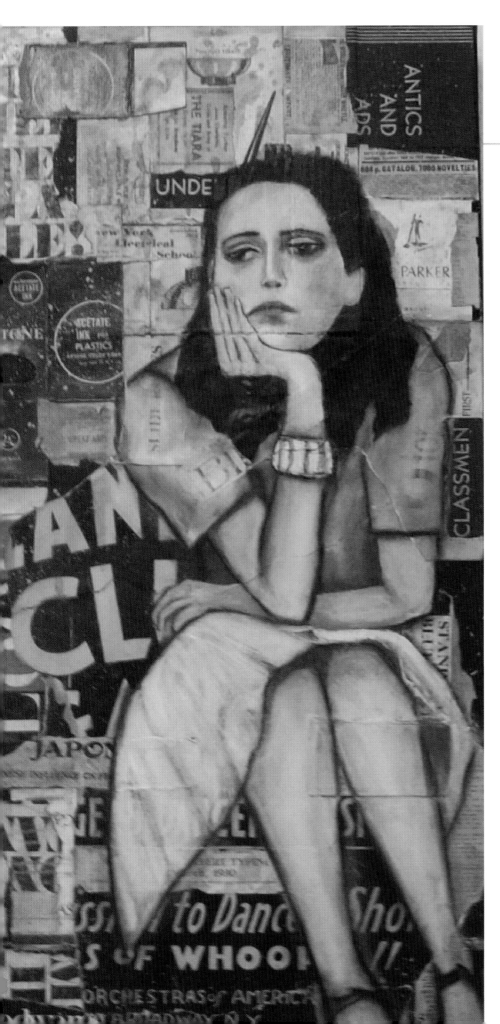

The Angst of Dora Maar

Marie Danti | 24" × 12" (61cm × 30cm) | acrylic paint, vintage ephemera, matte medium on gallery-wrapped canvas

I have been working with mixed media for many years, experimenting with a variety of materials, techniques and formats, collecting an assortment of supplies and vintage ephemera (which is a passion of mine). My objective was to create original work that would satisfy aesthetically and compositionally and also incorporate portraiture, which is my primary genre. In this case I chose to paint Dora Maar, the artist and Picasso's muse, based on a vintage photo that I love.

The result was so surprising and satisfying to me. It was as if all the years of experimenting and making art had all come together, exemplifying what I had been looking for all along. Everything worked; the palette, figure and background all came together as a whole piece. That happens relatively infrequently, and when it does, it feels miraculous, a dream realized.

" *Persist in your practice, and believe that nothing—not time, materials or longing—is wasted in realizing your dreams. And maybe most important, work from your heart with things that you love.* " • Marie Danti

*" **The wonderful thing about dreams is that if they don't come true, you can always dream up new ones tomorrow; so don't ever stop dreaming!**"* • Ronald Brischetto

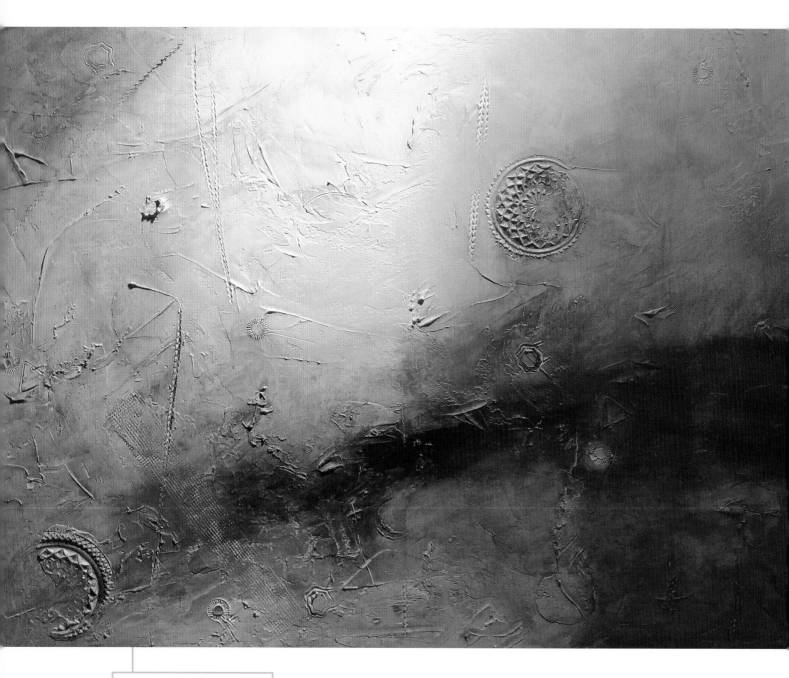

Terrascape #21

Ronald Brischetto | 30" × 40" (76cm × 102cm) | Venetian plaster, acrylic on stretched canvas

Have you ever had the urge to touch a painting? If you're like me, you're drawn to the tactile feel of art. Going beyond creating the illusion of texture with line, value and color, I've always tried to push the envelope to create a compelling piece to make the observer want to deliberately touch the art. I finally found what works for me: Venetian plaster.

In a twelve-step process, I layer plaster all over the canvas, while adding color with acrylic paint. Every layer needs to be applied thinly and built up to get that depth of texture. After applying the first layer, I inscribe designs before the plaster dries completely. This is using a technique called sgraffito. Adding more layers of plaster and paint continues, along with the inscribing, until a finished piece emerges. It's fun to watch people reach for the canvas, being tempted to touch it. I'm not alone!

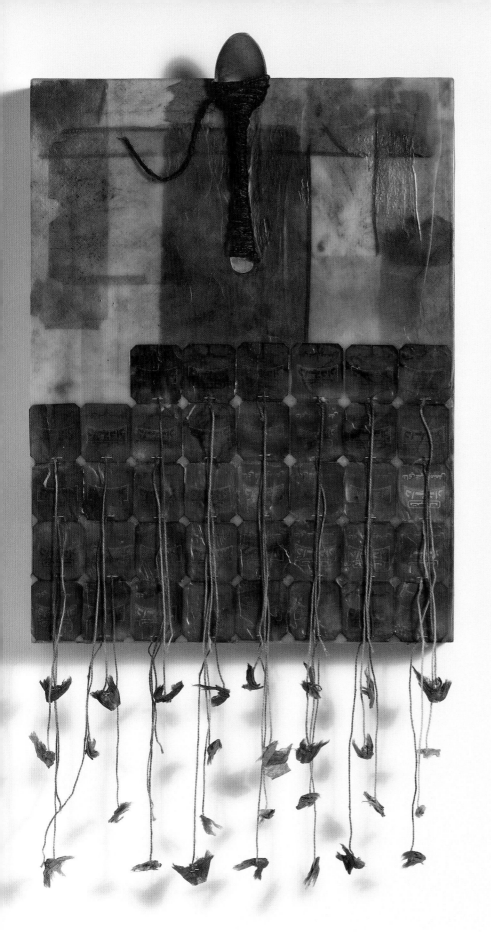

Bound by Ceremony

Nancy Yule | 12" × 9" (30cm × 23cm) | encaustic wax, teabags, spoon, twine

Artwork is an extension of the artist, the means to express our souls. Transforming the ordinary into the extraordinary, *Bound by Ceremony* consists simply of teabags, a spoon, twine and encaustic wax. Light and wind are unpredictable elements that play with the teabag ends still attached to their strings. The dancing shadows mimic birds in flight.

While focused on my work, I can only see through my eyes and feel from my heart. It wasn't until I could open my ears and listen to others' interpretations that I realized that my dreams were fulfilled. *Bound by Ceremony* had touched yet another surface—their hearts.

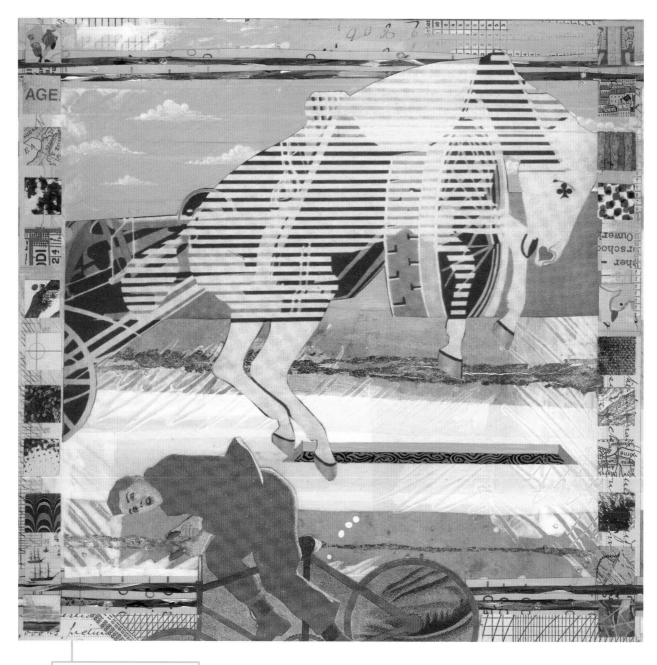

Fall into Place

Robert H. Stockton | 8" × 8" (20cm × 20cm) | mixed-media paper, acrylic paint, gouache and gold leaf on 140-lb. (300gsm) cold-pressed mixed-media paper

Beginning a piece in a familiar way and then, for reasons unknown, suddenly visualizing completely new possibilities is one of the delights of the creative process that both amazes and enchants me. It is one of the ways that this process helps us grow as artists. For this piece, looking through my ample stash of collage materials gave me the spark that provided the inspiration for this new direction. The two images—which I knew I wanted to incorporate into the piece—became the major visual elements of the composition. By carefully planning the exact placement of and relationship between these images in the composition, and then painting in the sky, clouds and pool, quite suddenly the piece had evolved into a landscape, and everything else, indeed, seemed to fall into place.

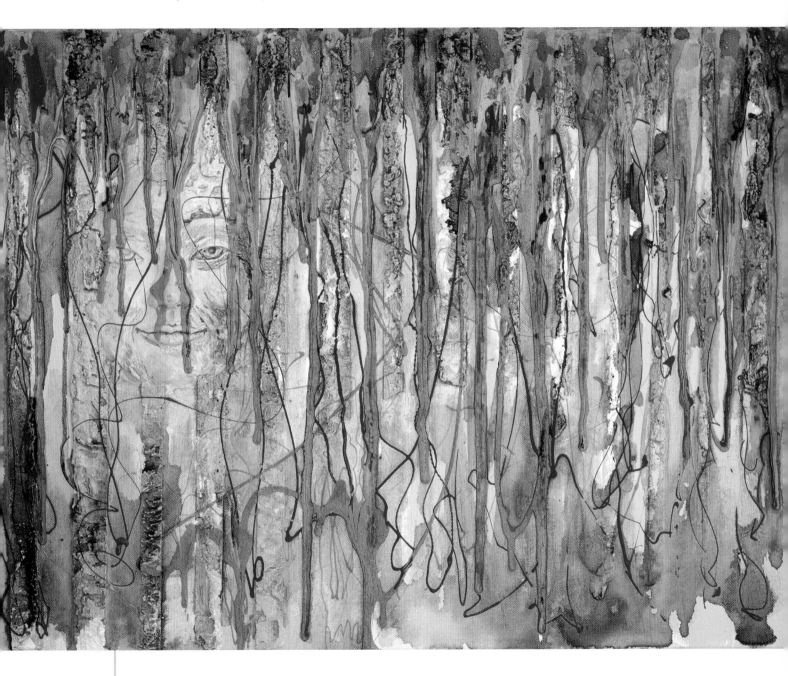

The Color of Light

Toneeke Runinwater Henderson | 18" × 24" (46cm × 61cm) | acrylic, texture gels on canvas

I find soothing happiness in the outcome of creating textured work with my hands and feeling the layers of medium take shape as a direct correlation to the state of my heart. Layers in my work represent the building blocks of my creative process. *The Color of Light* was built around a sculpted face, which implies depth, both poetically and in physical dimension. From that foundation, iterations of layers are creatively formulated and applied. The work is complete when I have arrived at the concept, story or energy I intended to convey.

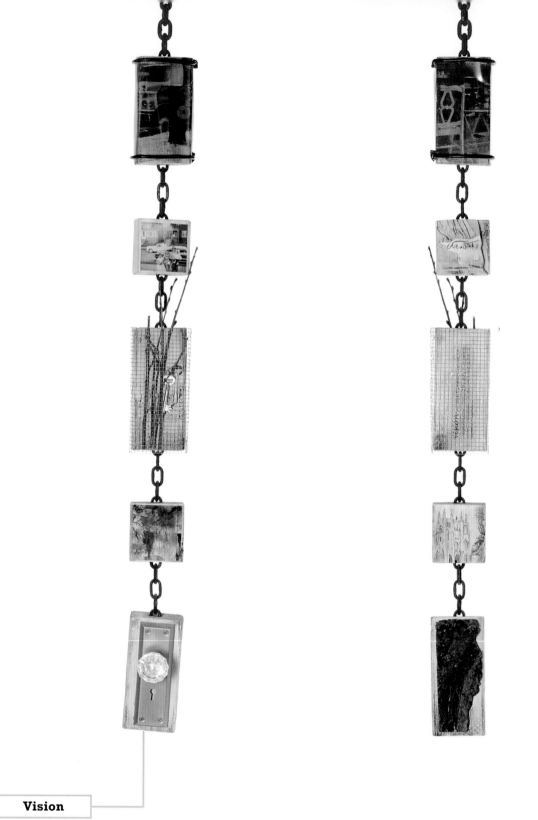

Vision

Lin Viglione | 44" × 4" (112cm × 10cm) | painted wood, clay, image transfers, transparency, computer cord, found objects

Vision made me realize that the vision and the artist are inseparable, and each defines the other. People always advise, "Draw what you know." I think it is more aptly stated, "Draw who you are, what you feel." It was intense emotionally to see that I included my family, my lineage, in the journey of this piece. Combining natural and spiritual influences with the concept of self is the key to this dream realized.

"*Mixed media has always appealed to me because it exemplifies my definition of art as the universal, silent language—impossible to describe, yet so easy to feel.*" • Lin Viglione

"After the preliminary assemblage stage, go back and use color as a means to bring harmony to the elements, enhance the tenor of the work and evoke a sense of nostalgia." • Catherine Hightower

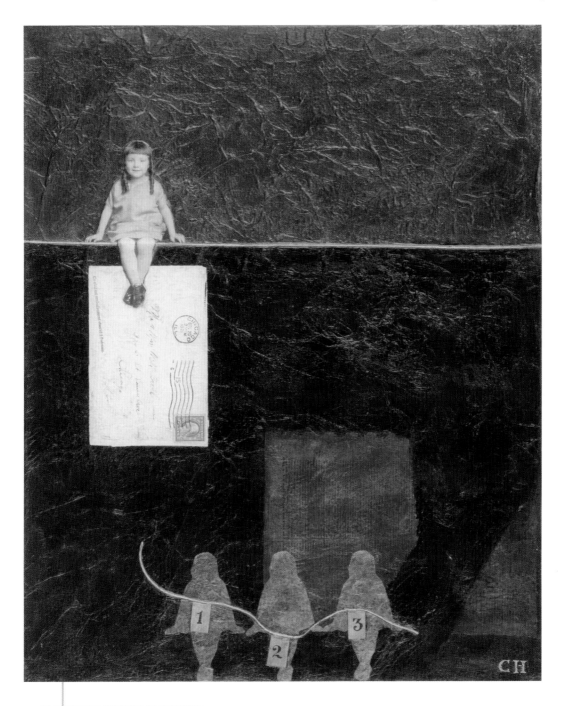

Girl on a String

Catherine Hightower | 20" × 16" (51cm × 41cm) | collage (printed ephemera, tissue paper, string, vintage photo, matte medium, acrylic paints) on canvas

Art gives voice to dreams that cannot be expressed in words. Because beauty can be found in the paraphernalia of everyday life, I root through boxes of time-worn maps, tattered postcards, vintage photos and odd scraps in corners of junk stores, searching for what Joseph Cornell referred to as "the light of other days." Occasionally I look into the eyes of a person in a sepia photo and feel an inexplicable connection. Such palm-size people inhabit my studio until I find just the right ephemera to accompany them. Each work is a highly personal experiment to reconstruct fragments of time, threads of the past interwoven with the present. What matters most to me is the degree of poignant emotion evoked by the artwork that allows the viewer a fleeting romance with time.

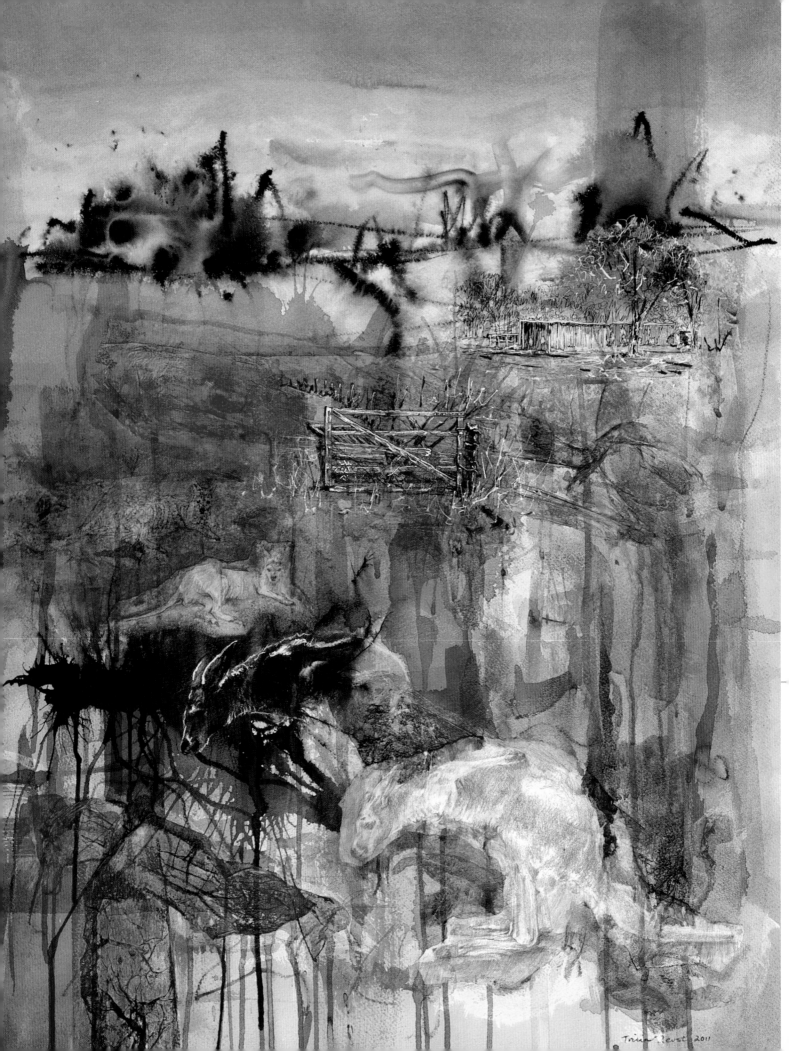

With this work, I wanted to hint at the regeneration that occurs in nature, no matter the neglect, and depict the resilience of the cycle of life. Abandoned farmhouses and deserted work buildings are frequent sights in the outback. They eventually fall and flatten to the earth and, along with the dreams of the former families working these areas, become added anonymous elements of the environment in which the animals continue to exist.

We are not separate from one another or the earth, and through this connection, we are responsible for how we treat each other and the earth. My dream is to convey this belief visually, and the mingled, fused edges of the mixed-media process help underline this connection.

Deliberate Vision
Future Intentions, Words to Live By, Messages Given

The vision for her art that an artist holds in her heart is like a lamp whose flame burns eternal—an intention imbued in the layers of paint or line or stitching. A vision can be specific and particular to one piece of art, but typically as artists, our vision is a reflection of what we value and carries through most of our work. Barbara Bazan makes it her mission to start a conversation with her artwork: "I like to lighten up onerous subject matter with amusing commentary and invite the viewer to interact with my pieces. I am delighted when a topic my art explores opens a doorway for dialogue with another."

For Rae Broyles, it's all about being a voice for ideas waiting to take on a visual form: "My purpose is to be the vehicle that the gift of art and creativity flow through—putting down on the canvas the images that exist in the universe, but have yet to be physically realized."

And Tricia Reust hopes her art encourages a connection to nature and the earth. As she puts it, "We are not separate from one another or the earth, and through this connection, we are responsible for how we treat each other and the earth. My dream is to convey this belief visually, and the mingled, fused edges of the mixed-media process help underline this connection."

I believe one vision shared by all of the artists in *Incite* is to inspire you, the reader, to realize your own dreams.

"*My dream for my art is to share a private moment, a part of my soul and a feeling of magic.*" • Marty Husted

In Proportion to Courage

Rae Broyles | 60" × 36" (152cm × 91cm) | mixed media on canvas

My intentions are simple. In the words of Gandhi, "Be truthful, gentle and fearless." I believe my work is successful in proportion to my courage and honesty. The best work I have done was, in my mind, only half-finished, because the art tells me when to stop, rather than me directing the art.

My purpose is to be the vehicle that the gift of art and creativity flow through—putting down on the canvas the images that exist in the universe, but have yet to be physically realized.

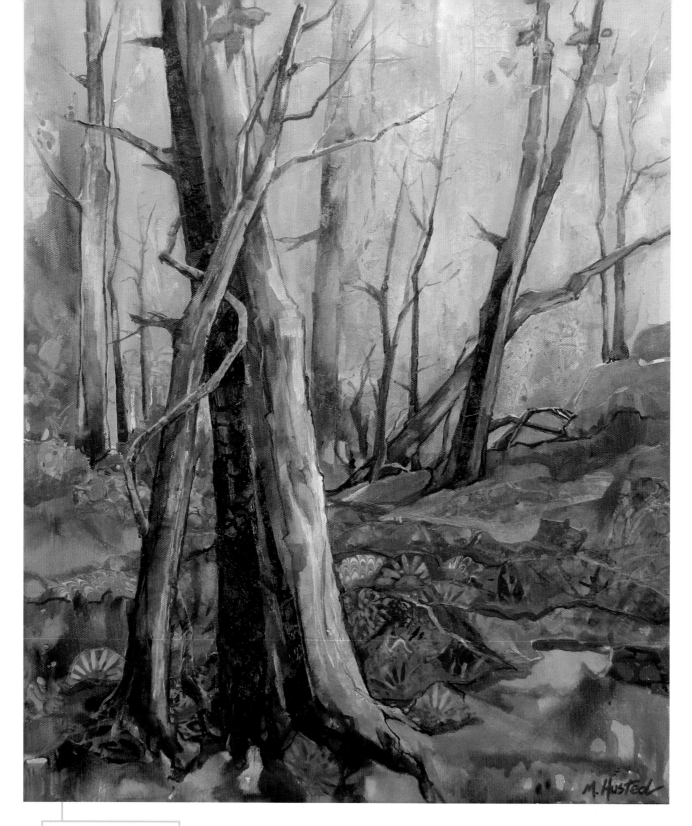

Rumination

Marty Husted | 20" × 16" (51cm × 41cm) | acrylic, mixed media on canvas

The grace, majesty and stillness of the forest always make it a place for me to contemplate and reflect. My goal for this painting was to create a surreal and unique landscape that evokes in the viewer the emotions I have when I'm surrounded by trees.

My technique involved pouring fluid acrylics on canvas, using the complementary colors yellow and purple. I then painted the image from my reference photo on top of this ground. I added patterned papers and fabric, integrating them into the painting with acrylics and gel medium.

" My dream for my art is to share a private moment, a part of my soul and a feeling of magic." • Marty Husted

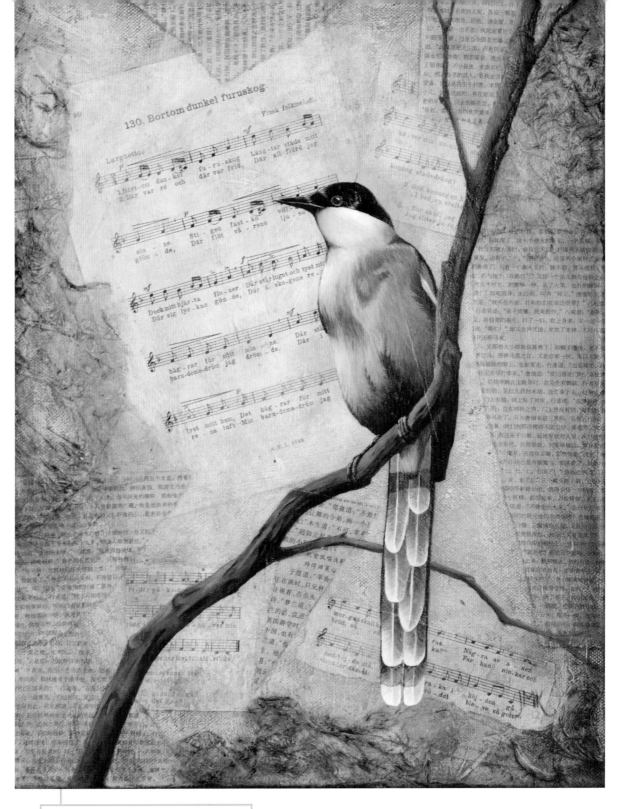

Beyond the Dark Forest

Jenny Moed-Korpela | 16" × 12" (41cm × 30cm) | acrylic, oil, book pages, paper on canvas

This was one of those painting experiences where everything flowed, as if this image was just waiting to be painted.

The title of this painting is a translation of the Swedish song on the sheet music in the background, and this gave me the inspiration for the colors and atmosphere I tried to achieve.

The background is, for me, as important as the subject. I wanted to create the atmosphere purely with texture and color, painting a totally abstract image before adding the realistically painted bird.

I achieved the same playfulness as in my first initial sketch, and at the same time, captured the feeling of a secret life of this beautiful azure-winged magpie, just as I had visualized it.

Charlie's Squares

Carol A. Staub | 22" × 22" (56cm × 56cm) | acrylic, colored pencil on Aquarius 80-lb. (170gsm) watercolor paper

Every time I reach for a new sheet of paper or canvas, my dreams have truly been realized. I began painting late in life (twelve years ago) and have always been amazed at the sense of freedom I feel each time I approach a new painting. This particular painting was painted in honor of my brother, who recently passed away. He would have loved the happy colors and the puzzle-like squares.

Afternoon Sail on Broad Creek

Melissa S. Walker | 30" × 30" (76cm × 76cm) | acrylic paint, stamps, collage on canvas

My current series incorporates nautical charts as collage. I use many types of charts that I have collected from family and fellow sailors. I begin by underpainting with Cadmium Red acrylic, and then adhere collage with acrylic matte medium. As I build the surface, I use a variety of combs and stamps to add texture and movement, while trying to capture the essence of the ocean and the areas around it. Some will see the image as a bird's-eye view, much as you would view a map. Others will see the same painting as a landscape, with the traditional sky, horizon line and water.

Mr. Sunshine

Jennifer Rodriguez | 35" × 27" (89cm × 69cm) | fused raw appliqué, textile art, hand-embroidery

In 2012, I decided to focus my attention on textile art. This dream meant losing a steady income, embracing a more controversial vision and tuning out social norms. This was my first piece that I allowed myself freedom and discovered my dream realized. I've since created more personal visions, with many more to come. *Mr. Sunshine* is a colorful reminder that death comes to us all. It is up to us to live our dream in the time we have.

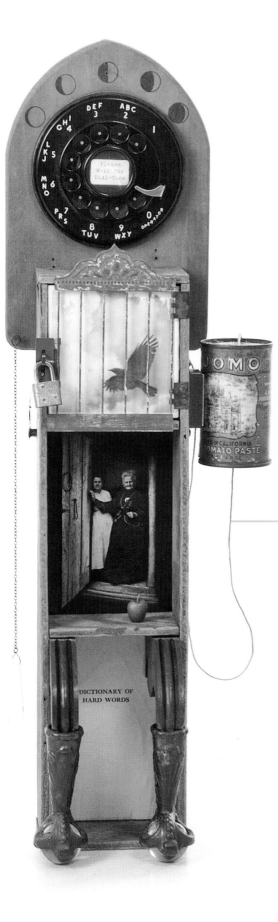

The Inquiry

Barbara Bazan | 24" × 8" × 6½" (61cm × 20cm × 17cm) (including attached components) | acrylic paint, gel medium and blender marker transfers, oven clay, colored pencil, old objects, paper ephemera, digitally altered photos

I enjoy searching for and finding a use for the old objects and ephemera that animate my work. They stir my memories and emotions and aid me in uncovering my personal mythology. I like to lighten up onerous subject matter with amusing commentary and invite the viewer to interact with my pieces. I am delighted when a topic my art explores opens a doorway for dialogue with another. For years I put aside my desire to explore artistic expression. That pesky time element was a major stopping point for me. Now, because of generous folks eager to share their techniques as well as the expanding technology available today, I have found that an idea can quickly evolve into a finished piece.

"I encourage anyone waiting for their right time to allow that time to be now." • Barbara Bazan

Joyce

Paula Drysdale Frazell | 40" × 30" (102cm × 76cm) | acrylic paint, fabric, photographs on stretched canvas

Collage is the medium that allows me to express my artistic vision. As a collagist, I strive to make different elements work together successfully, to speak in one voice. For this portrait of my mother, I combined acrylic paint, fabric and photographs. It has always been a goal of mine to present her warm, elegant spirit with my art.

The top of the gown—actual photographs of my mother—creates the feel of a 1960s black-and-white pop-art fabric, while the warm backdrop palette best supports both the top and full skirt. Lush earth tones and gold work together to represent her elegance.

This is a tribute to my mother—a warm, creative, effortlessly stylish woman—and is a thrill for me, a dream realized. Joyce is ready for her close-up!

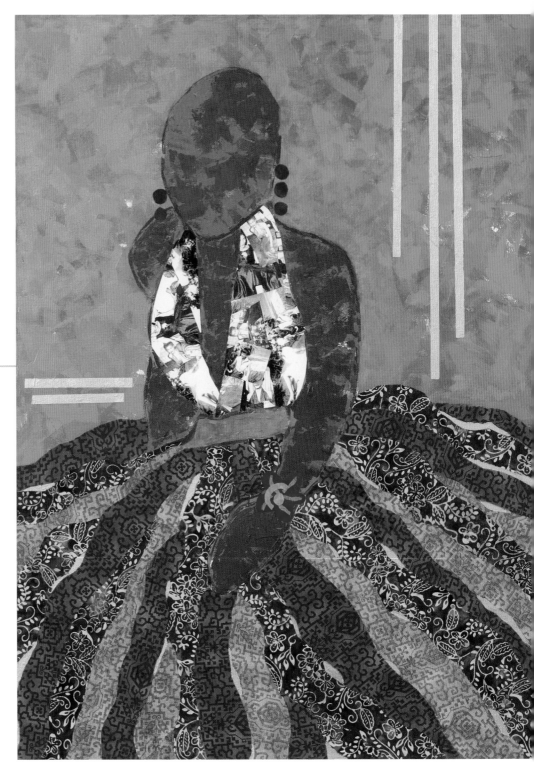

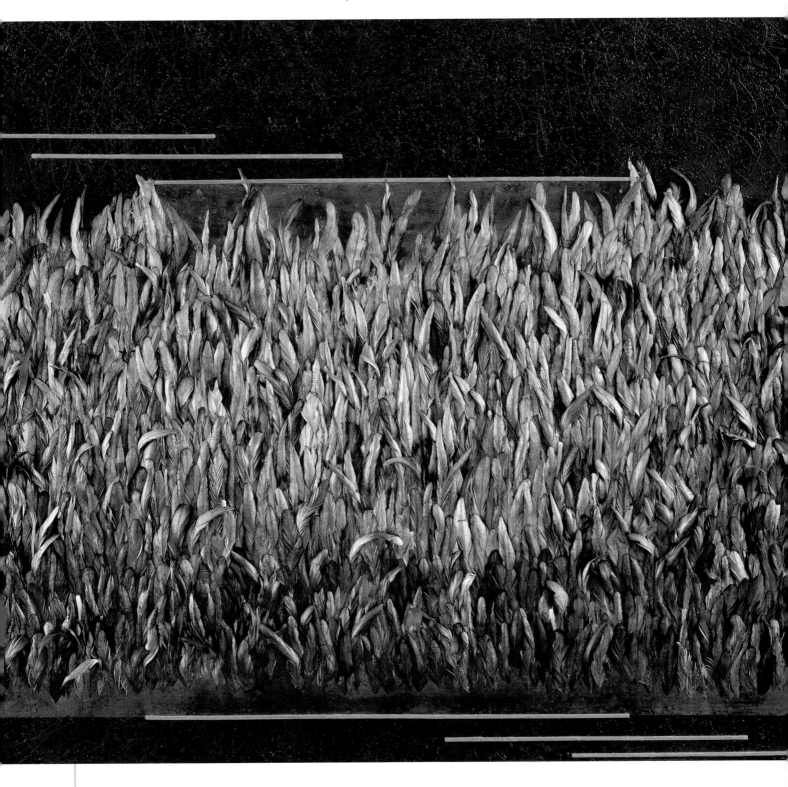

C'hien—Map to the Mountain

Nicki Marx | 40" × 44" (102cm × 112cm) | coq feathers dyed in real silver, encaustic

My dream is of a natural world, pristine and vital. I work only with natural materials in order to honor and celebrate the beauty and precious essence of nature. It is my hope that my work will be a reminder of what we have and what we stand to lose if we do not pay attention. Sadly, this dream is yet to be realized.

When We Fell in Love

Christine O'Brien | 12" × 12" (30cm × 30cm) | acrylic, collage on wood panel

This piece came about while creating works for a solo show. It was also a busy period with little time for creating. With a deadline looming, I created quickly, intuitively, and truly discovered my own voice.

It was my best work to date—layers of acrylic and collage in arrangements that reflect the colors, patterns and textures found in nature, a reprieve from the daily hustle. My goal was to create art that took me away, works where I imagined being in touch with the earth—moving through grass, meditating by a landscape, experiencing simple things the soul can enjoy.

When I delivered the works to the gallery director, she commented that they looked to be created by nature itself. I couldn't have wished for more.

The Pathless Woods

Jami Tobey | 36" × 36" (91cm × 91cm) | acrylic, pen and ink

This work invites us to return to that same fascination we experienced as children when we ventured deeper into the forest, set fire to our imaginations, camped under a blanket of stars, married strange sounds and smells, heard the lonely bugle of the elk, fished with our fathers, studied the endless relationship of branches, twigs and leaves, and danced to the rhythm of the seasons.

Nature wears many faces: It can be achingly beautiful, sometimes frightening, but always alive and breathing.

With some imagination, and perhaps a little luck, my paintings recall that sort of magic that nature once provided us in generous amounts. And the acrylic, stained-glass appearance that threads through the work might suggest an almost religious devotion to the subject matter that enables us to remember what we've lost along the way, to step outside and to breathe for the first time in years.

Contributors

Brenda Abdoyan
San Francisco, CA
Brenda.Abdoyan@bajidoo.com
•p30, front flap Steam Punk Aviator

Lisa Agaran
626.470.7278
lisa@artbylisaagaran.com
artbylisaagaran.com
•p64 Lake of Dreams
•p112 Heaven and Earth

Sarah E. Alexander
WSA, NAA, FAA
Hopedale, MA
Wanderingmindstudio.com
•p54 Letting Go

Daven Anderson
AWS, MWS, NWS
1808 Hickory St., St. Louis, MO 63104
314.241.2339
DavenAAnderson@gmail.com
davenanderson.com
Ober Anderson Gallery, St. Louis, MO
•p21 'Tis the Season

Susan Ashbrook
Cumberland, Ontario, Canada
ashbrookcreative@gmail.com
SusanAshbrook.com
•p37, back cover Imagination

Becky L. Bane
PSWC, PAAR, RAM
Riverside, CA
rebekahart@me.com
rebekahart.com
•p69 Self-Portrait

Joy Bathie
133/33-93 Spinifex Ave., Tea Gardens, NSW 2324,
Australia
0011 61 2 4997 9610
jvar@bigpond.com
•p58 Quotes for Life
*One of six limited editions in private collections

Barbara Bazan
Big Rapids, MI
bebazan@gmail.com
•p131 The Inquiry

Élise Meredith Beattie
NAWA, NWWS/SW, FWS
P.O. Box 7829, Paducah, KY 42002
270.994.9377
artist@embart.com
embart.com
•p29 Jungle Management

Aaron Bell
FASO, AWS, IWA
208.860.8396
aaronbell@ruiinc.com
Green Chutes Art Gallery, Boise, ID
•p83 Beguiling

Sandie Bell
Sandiebell416@gmail.com
Sandiebellart.com
Andre Christine Gallery, Mooresville, NC
•p20 Japanese Marketplace (Veno Amoyoko)

Carole Belliveau
OPA, MBPAPA, PSA
Carolebelliveau@gmail.com
Carolebelliveau.com
•p78 Golden Child

Patricia Bradley Bereskin
LBAL, QCAL, A Fine Line Artist Workshops
Bettendorf, IA
mrsbsart@gmail.com
patbereskin.com
•p14 Between the Lines

Julie Birman
Arts Council of Greater Kalamazoo
793 Topview Dr., Otsego, MI 49078
269.998.3983
jbirman@charter.net
•p86 Arrival

Marnie J. Blum
mjbart@live.com
marniejblum.com
•p88 Exposed

Kathy Brandenberger-O'Rourke
4007 Hillswind, San Antonio, TX 78217
210.325.2516
kcbo49@yahoo.com
St. Charles Gallery, Rockport, TX
•p43 Transformation

Sue Brassel
Crawfordsville, IN
sue@suebrassel.com
suebrassel.com
creativeLAB, Crawfordsville, IN
•p85 Looking for Adventure

Ronald Brischetto
ISAP-FL, PAVA, TESA
3316 Covered Bridge Dr. East, Dunedin, FL 34698
727.744.5169
rbfla@email.com
ronaldbrischetto.com
Stirling Art Studios and Gallery
•p116 Terrascape #21

Rae Broyles
Atlanta, GA
raebroyles@me.com
raebroyles.com
•p124 In Proportion to Courage

Beth Keitt Brubaker
TAEA
16250 Morningbrook Dr., Spring, TX 77379
281.279.1678
keittoodles@aol.com
keittoodles.com
•p56 28 Plates, Before and After

Carole A. Burval
TWSA WHS, MOWS
Barrington, IL
carole@watercolorcards.com
caroleaburval.com
•p38 Faced with Reality

Molly Cassidy
onceuponathyme@netscape.net
papernymph.com
fitzgeraldfinearts.net
•p28 Liberation
•p105 Darkest Before the Dawn

Juliana L. Coles
829 San Lorenzo NW, Albuquerque, NM 87107
505.341.2246
meandpete@msn.com
meandpete.com
•p92 Let It Rain
•p93 This Is Mine

Kathy Kostka Constantine
kkc@olympus.net
•p13 Souvenirs de Paris (Memories of Paris)
*Merit Award at Northwind Arts Pieceworks show

Diane Cook
5907 T St., Katy, TX 77493
281.924.9476
rosajosies@yahoo.com
rosa-josies.blogspot.com
•p81 Hope Flies

Linda Cotter Cowles
Lansing, MI
517.507.1072
lindacowles.art@gmail.com
•p96 Getting from A to B
•p108 Count to Three

Marie Danti
Boulder, CO
Cinnamonstudio.blogspot.com
•p115 The Angst of Dora Maar

Georgia P. Doubler
TWS, GWS (Signature Member), TCA
1571 Placita Embate, Green Valley, AZ 85622
520.625.0066
Cell: 520.349.8507
rgdoubler@cox.net
•p110 Mexican Façades
•p111 Moth and the Flame
Mexican Façades, Kingsport, TN Art Guild
Best of Show
Mexican Façades Collection of Dr. and Mrs.
Robert Hawk, Kingsport, TN
Moth and the Flame Collection of Norma
Wilkerson, Tumacacori, AZ

Fran Dussaman
Show Low, AZ
Reclusivegoddess.blogspot.com
•p74 Desperado
*First place, 3-dimensional Art Alliance of the
White Mountains

Abby Feinknopf
OAL, ODC, SCBWI
263 S. Ardmore Rd., Columbus, OH 43209
614.239.9096
afeinknopf@gmail.com
abbyf.com
•p82 Morton Salt

Tejae Floyde
PPPCG, MHPCG
Colorado Springs, CO
Tejaesart.com
•p80 Dreams Encased Heart

Paula Drysdale Frazell
NCS
frazellpaula@yahoo.com
•p132 Joyce

Elyse Marie Frederick
704.806.6039
elyse.marie@yahoo.com
•p41 Cat TV

Karen S. Furst
Trilbyworks.com
Bellefonte Arts Gallery
•p6, 12 The Servants of Ord

Francesca Galliano
9525 SW 163 Ct., Miami, FL 33196
305.205.6074
francescagalliano@htomail.com
•p102 Between Heaven and Earth: In the
Garden Where Hopes and Dreams Dwell—
View 1
•p103 Mystic Portrait: Spirit View XIV—The
Triune Self
Between Heaven and Earth-First place in
sculpture 2012, Carnaval on the Mile, Coral
Gables, FL; Outstanding Achievement, 2011
Chicago Botanic Garden Art Festival
Mystic Portrait-First place in mixed media, 2011
Art in the Park Miami, FL; First place in mixed
media, 2011 Pine Crest Gardens Fine Art Festival

Jose Gallo
Atlanta, GA
Josegallo.com
•p68 Don't Give Up
•p114 Emerging Lines
Emerging Lines-Finalist, Beyond the Dot, Savannah
College of Art and Design, Atlanta, GA
Emerging Lines-Red Clay Survey, Huntsville Museum of
Art, Huntsville, AL

Gayle Gerson
CWS, WCWS, RMCS
Grand Junction, CO
galstarr@bresnan.net
gaylegerson.com
The Blue Pig Gallery, Palisade, CO
•p51 Three Martini Lunch
*Merchandise Award, Rockies West National

Tari "TJ" Goerlitz
Studio Mailbox
Studiomailbox.com
•p63 Call and Answer

Annie O'Brien Gonzales
9 Madrona Circle, Santa Fe, NM 87506
505.699.1705
anniego@mac.com
annieobriengonzales.com
The Matthews Gallery, Santa Fe, NM
•p2 Tulipmania

Mel Grunau
ISAP, PAA, OWS (Charter Member)
Mjgrunau.com
•p49 Encore

Julia Hacker
Artists in Canada, CARFO
40 Foursome Cross, Toronto, Ontario M2P1W3, Canada
416.256.9556
juliahacker@rogers.com
juliahackerart.com
•p18, 24 Travel Diary
•p101 Under the Clouds

Toneeke Runinwater Henderson
SAAG, AVA, ACA
P.O.Box 247, Calhoun, TN 37309
423.336.5877
toneeke@gmail.com
toneeke.com
Galleries on West Main, Blue Ridge, GA
•p119 The Color of Light

Catherine Hightower
Ann Arbor, MI
Catherine@hightower.org
•p121 Girl on a String

Karlyn Holman
318 W. Bayfield St., P.O. Box 933, Washburn, WI
54891
715.373.2922
karlyn@karlynholman.com
karlynholman.com
Karlyn's Gallery
•p48 Path of Light

Terry Honstead
10586 Quarterhorse Circle NE, Tenstrike, MN 56683
218.407.4881
honstead@paulbunyan.net
terryhonstead.artistwebsites.com
terryhonstead.wordpress.com
terry.honstead.blogspot.com
•p90 Summer Blossoms

Marty Husted
ISEA, OPAS
614.267.9304
mahusted1@yahoo.com
martyhusted.com
Studios on High Gallery
•p126 Rumination

Aleta Jacobson
AAIE, PVAA, SCCS (President)
1040 Northwestern Dr., Claremont, CA 91711
909.241.2131
a.jacobson511@gmail.com
aletajacobson511art.com
•p62 Leaving
•p77 Porch Door
•p97 She's in There

Laura Lein-Svencner
NCS, MCS
6718 Dale Rd., Darien, IL 60561
lonecrow4@gmail.com
lauralein-svencner.com
•p55 Journey
•p65 Wide River
•p91 Singing My Song

Mariette Leufkens
707.364.9618
mariette@marietteleufkens.com
marietteleufkens.com
•p9 Leonardo's Day Spa

Valerie Lewis Mankoff
NAWA, SLMM
Valeriem713@gmail.com
Valeriemankoff.artspan.com
•p11 Microcosms, Part I

Jenny Manno
805.660.5548
Mannojv@aol.com
•p50 Memories of Paris
•p61 Red Meal Ticket

Nicki Marx
P.O.Box 128, Penasco, NM 87553
575.779.7097
nickimarx.com
Marx Contemporary Gallery, Penasco, NM
•p133 C'hien—Map to the Mountain

Amanda Beck Mauck
322 Highfalcon Rd., Reisterstown, MD 21136
abeckmauck@gmail.com
amandabeckart.com
Art Underground, Hampden, MD
•p16 Gypsy

Candy Mayer
EPAA, PS of El Paso, PAP of El Paso
1317 Tierra Roja, El Paso, TX 79912
915.581.4971
cc2ccmayer@aol.com
candymayer.com
Sunland Art Gallery, El Paso, TX
•p76 La Frontera
*Juror Award, Arts International Exhibit, El Paso
*Desert Modern: El Paso Art 1960—2012 exhibit
at El Paso Museum of Art

Raven Skye McDonough
Venice, FL
603.361.3821
raventree44@hotmail.com
RavenSkyeMcDonough.com
•p34 21st Century Athena

Laly "Lalyblue" Mille
Lalyblue.art@gmail.com
Lalyblue.com
•p98 Touch the Dream

Jenny Moed-Korpela
Jennymoedkorpela@yahoo.com
Jennymoedkorpela.com
•p127, cover, Beyond the Dark Forest
*Special Recognition Award in Animals Art
Competition from Light Space and Time Online
Art Gallery

Colleen E. Monette
IEA, Artwalla
Colleen.monette@yahoo.com
Colleenmonette.com
•p17 Hands

Judy Morris
AWS, NWS, TWSA
4782 Auburn Lane, Lake Oswego, OR 97504
503.635.1418
judy@judymorris-art.com
judymorris-art.com
Hanson Howard Gallery, Ashland, OR
•p70 My Garden Pond
•p71 Italiano Classico

Sharon J. Navage
NAWA, WPA, Printmatters Houston
navageco@sbcglobal.net
sjnavage.com
Mariposa Gallery, Albuquerque, NM
•p72 On Wings of Light
•p75 The Window Box

Crystal Neubauer
crystalneubauer@yahoo.com
crystalneubauer.com
Xanadu Gallery, Scottsdale, AZ
•p99 Deep Calls to Deep

Christine O'Brien
GFA, NAA
Studios at Porter Mill, 95 Rantoul St. #2-5,
Beverly, MA 01915
978.828.2460
christineobrienart.com
•p134 When We Fell in Love

Karen E. O'Brien
Quietbear2@gmail.com
Keobrien.com
Karenobrien.blogspot.com
•p109 Kokoro of the Sea

Eve Ozer
MCS, EAG, WAC
102 Kenmare Dr., Burr Ridge, IL 60527
630.258.4437
eveozer@mdgglobal.com
eveozer.com
LaGrange Art Gallery
•p84 So, Where Do I Go from Here?
*First Place, 2012 Elmhurst Artists' Guild Fall
Exhibit, Guild Gallery, Elmhurst Museum,
Elmhurst, IL

Barbara Pask
WACC, MDAA
Mason, OH
barbarapask@zoomtown.com
lovetopaint.blogspot.com
•p36 Wedding Gown

Sandrine Pelissier
AFCA, SDWS, NWWS
171 W. Kings Rd., North Vancouver, BC U7N 2L7,
Canada
Sandrine@mixed-media-paintings.com
Mixed-media-paintings.com
•p32 White Coffee
•p33 Recycling Life

Kristin Peterson
323 W. Main St., Luverne, MN 56156
507.283.3935
Cell: 507.290.0265
alteredstatesstudio@yahoo.com
alteredstatesstudio.blogspot.com
HGS Gallery
•p106 Dayzees

Suzy "Pal" Powell
SWS, WYWS, CFAI
Suzy-pal2000@yahoo.com
Suzypal.com
•p44 Anchors Aweigh
•p45 Karla

Judith Randall
Judyloveslaguna@aol.com
•p94 Actualization

Grace M. Rankin
SCVWS, CWA, FAA
Freemont, CA
gracemrankinartist@gmail.com
gracenotesbygracerankin.blogspot.com
•p42 Charlie

Lisa Renner
lisarenner@tx.rr.com
lisarenner.com
•p46 True Colors

Tricia Reust
PSA, PSA
reust@powerup.com.au
triciareust.com
•p122 A Crying Shame
*First Place, Kenilworth Landscape Prize

Lesley Riley
Lesley@lesleyriley.com
Lelseyriley.com
•p35 A Second Nest

Jennifer Rodriguez
9188 Granada Hills Dr., West Jordan, UT 84088
480.882.1063
allthingsbelle@hotmail.com
allthingsbelle.com
•p130 Mr. Sunshine

Mary R. Rork-Watson
NCS
2014 2nd Ave. SE, Altoona, IA 50009
mrwstudio@gmail.com
•p10 Dreams

Stephanie Jones Rubiano
5612 Sunny Vista, Austin, TX 78749
info@stephanierubiano.com
stephanierubiano.com
Austin Art Garage, Austin, TX
•p47 Aloft

Sharon Sandel
Weaverville, NC; Vero Beach, FL
Sbs787@comcast.net
•p25 Copper Field
*Honorable Mention, 2012 Red House Gallery
Summer Show

Trudi Sissons
Canada
Trudisissons@shaw.ca
Twodressesstudio.blogspot.com
•p8 Night Sky

Eileen F. Sorg
SAA, WPW, CPSA
P.O.Box 1616, Kingston, WA 98346
360.536.2047
twodogstudio@msn.com
twodogstudio.com
•p60 The Power of Self Esteem
•p95 Foiled Again

Loryn Spangler-Jones
1127 Maple Ave., Lancaster, PA 17603
lsjmixedmedia@gmail.com
lsjmixedmedia.com
Annex 24 Gallery, Lancaster, PA
•p113 Possession

Nancy Stanchfield
nancy@stanchfieldart.com
stanchfieldart.com
Ramey Fine Art, 73-400 El Paseo, Palm Desert, CA 92260
•p22 Promenade
•p23 Carnaval
•p40 Blossoms on Blue
•p104 French Façade

Carol A. Staub
ISEA, SDWS, FWS
10316 Crosby Place, Port St. Lucie, FL 34989
772.466.4386
carolcando@aol.com
carolstaub.com
The Wit Gallery, Lenox MA
•p26 Piano Man
•p27 Sidewalk Series No. 14
•p128 Charlie's Squares

Pat Stevens
6684 E. Lake Rd., Auburn, NY 13021
patstevens@patstevensart.com
patstevensart.com
•p15 From The Tapestry of Truth and Beauty

Robert H. Stockton
P.O. Box 122, Mukilteo, WA 98275
425.355.3532
Cell: 425.923.0094
Scrapbox9@gmail.com
Absolutearts.com/scrapbox
Everydayikons.blogspot.com
•p118 Fall into Place

Beryl Taylor
Monroe Township, NJ
beryltaylor@aol.com
beryltaylor.com
•p89 Synchronicity

Jami Tobey
LJAA
25490 Knollwood Dr., Murrieta, CA 92563
951.440.5838
jamitk@yahoo.com
jamitobeystudios.com
Gallery 822, Santa Fe, NM
•p135, front flap The Pathless Woods

Rosa Ines Vera
118 Via Finita St., San Antonio, TX 78229
210.451.8041
rositavera@aol.com
rosavera.com
•p66 Breed Crows (Cria Cuervos)
•p67 Departure (Salida)

Lin Viglione
Sterling Heights, MI
•p120 Vision

Myrna Wacknov
NWS, SDWS, CWA
675 Matsonia Dr., Foster City, CA 94404
650.574.3192
myrnawack@prodigy.net
myrnawacknov.blogspot.com
myrnawacknov.com
•p52 Home Alone
•p53 What About Evelin
•p100 Fragments

Melissa S. Walker
PSNC, WSNC
6139 Auman Farm Rd., Seagrove, NC 27341
336.460.1411
Melissa@melissawalkerartist.com
Melissawalkerartist.com
Melissawalkerartist.blogspot.com
Brightside Gallery, Asheboro, NC
•p129 Afternoon Sail on Broad Creek

Michael Weiss
6925 Rolling Ridge NE, Canton, OH 44721
330.493.3131
Cell: 330.445.9982
mtweiss@rocketmail.com
michaelweiss.carbonmade.com
mtweiss.wix.com/portfolio
Evolution Art, Canton, OH
•p4 The Boat
*First Place Fine Art, 2011 Joseph Saxon
Gallery of Photography
*Third Place 2012, Valley Art Center

Gia Whitlock
giatw@me.com
giatw.com
•p79 Flow

Nancy Yule
82 The Greenway, Cambridge, Ontario, Canada
N1R 6L9
Nancy@nancyyule.com
Nancyyule.com
•p117 Bound by Ceremony

Index

About the Editor

Tonia Jenny (formerly Tonia Davenport) is the acquisitions editor and senior content developer for North Light Mixed Media. A mixed-media artist and jewelry designer herself, Tonia has authored two North Light books: *Frame It!* and *Plexi Class*. When she's not busy making art, cooking, reading or exploring new ways of looking at the world, you can find her on Facebook.

fwmedia.com

Distributed in Canada by Fraser Direct
100 Armstrong Avenue
Georgetown, ON, Canada L7G 5S4
Tel: (905) 877-4411

Distributed in the U.K. and Europe by F&W Media International LTD
Brunel House, Newton Abbot, Devon, TQ12 4PU, England
Tel: (+44) 1626 323200, Fax: (+44) 1626 323319
E-mail: enquiries@fwmedia.com

Distributed in Australia by Capricorn Link
P.O. Box 704, S. Windsor, NSW 2756 Australia
Tel: (02) 4560 1600
Fax: (02) 4577 5288
E-mail: books@capricornlink.com.au

Editors: **Tonia Jenny & Amy Jones**
Designer: **Brianna Scharstein**
Production Coordinator: **Greg Nock**

METRIC CONVERSION CHART

CONVERT	TO	MULTIPLY BY
Inches	Centimeters	2.54
Centimeters	Inches	0.4
Feet	Centimeters	30.5
Centimeters	Feet	0.03
Yards	Meters	0.9
Meters	Yards	1.1

Acknowledgments

This book would not be the beautiful collection of works that it is without the incredible contributions of the artists who submitted their art. Thanks so much to all of you who were willing to take a chance and to allow us to inspire everyone who flips through these pages.

This book would also not exist without the editorial dedication and endless organization of Amy Jones; the production know-how of Greg Nock; the creative eye of Brianna Scharstein; and the passionate support of Jamie Markle, Mona Clough and the rest of the hard-working North Light team.